the artist within

A Guide to Becoming Creatively Fit

WHITNEY FERRÉ

Trade Paper Press
An Imprint of Turner Publishing Company

200 4th Avenue North • Suite 950
Nashville, Tennessee 37219
(615) 255-2665

www.turnerpublishing.com

the artist within: a guide to becoming creatively fit

Library of Congress Cataloging-in-Publication Data

Ferré, Whitney.
 The artist within : a guide to becoming creatively fit / Whitney Ferré.
 p. cm.
 Includes bibliographical references.
 ISBN 978-1-59652-407-1
 1. Art--Technique. 2. Creative ability. I. Title.
 N7430.5.F48 2008
 702.8--dc22

 2008035375

Cover Design by Michael Penticost and Megan Munroe
Interior Design by Megan Latta and Whitney Ferré
Edited by Steven Cox

Printed in the United States of America

12 13 14 15 16 17 18 19—10 9 8 7 6 5 4 3 2

Creativity is not just for kids, artists, and homemakers, it is for everyone who needs to create a degree of change.

Contents

Acknowledgments

Each of us has an amazing opportunity every day and in every situation to empower others! We can give them that extra little push, a shot of confidence, or simply a positive word when they are feeling doubtful. When we help others to believe in themselves and support their actions, amazing things can happen! Little things and big things. This book is a little thing. It can fit inside most purses or perch on a small bedside table, but for me it is a big thing. The "big things" don't come around in life that often. I am so grateful to have this opportunity. It never would have manifested itself had it not been for all the people over the last decade who got excited about discovering their *artist within* and who have circled around my Creatively Fit movement. It is an idea that warrants our national attention. We need a community that feels confident in its ability to create change. We need a national community that is creatively fit.

This book is the mustard seed that can grow into a really big thing. Now it is up to you. Share it with friends and colleagues. Bring it to the book club. Believe in yourself and in your ability to create whatever change you would like to see in your own world, little change or big change. Be aware of the voice in your head that tells you that you can't change. Let this book be the voice that tells you that you can!

Thank you, Peter, Christy, Susan, Geoff, Dane, Jordan, Riley, Mason, Alice, Todd, and all of my friends and family who were the voices that told me, "This is a big thing. You can do it!"

Introduction

You have ideas and a desire to express them. They may be big, medium, or small. You may want to start your own business or simply rearrange your living room. You may have an idea for a product that you envision on retail shelves or an idea that would bring your neighborhood together. You may just be tired of your routine and need a new direction. You want to create, and to make your creative ideas real, but something is holding you back. It could be the daily grind; it could be fear of failure; it could be the uncertainty of where to start, but you know you want to start something. The "box" that currently defines you has become outdated. "There has to be something else," you say. If this is how you feel, this book is for you.

What This Book Will Do For You

This book is going to introduce you to your artist within. It is there, waiting. It is a voice inside your head that speaks to your hopes and dreams; it never tells you that you cannot succeed. All you need to do is unlock the voice, and this book is the key to doing just that. This book is going to help you transform the ideas in your head into reality, just as an artist takes the images in her head and transfers them to the canvas. This book simplifies the path to discovering your creativity into achievable steps, nice and easy.

"I'm not creative." This is what your left brain is probably whispering to you right now. This book is not for artists. This book is no more for the Martha Stewarts of the world than for the Alan Greenspans. This book is for all the people who "can't even draw a straight line." This book is for everyone who wants some kind of change in his life. Whenever change occurs, something has been done differently. If you want change, *you* have to do *something* different. You may not feel confident in your ability to create change. That is because you have not stimulated that side of your brain, **your artist within.**

Think of it this way. Before there was a monetary system or a written language, there was art. As humans, we have been creating art longer than almost any other activity. Each of us has an innate desire and ability to express

11

ourselves visually. It was not so long ago that every piece of food on our plate, the chair we sat in, the clothes on our back all came from our own hands. These days, we needn't create anything. We can order out, order online, and shop around the globe without ever saying, "Look what I made." Our confidence in our ability to create change has been sabotaged by the luxuries of modern living. **Your artist within is an ancient voice that will help you to create the change you desire.**

> *When the artist is alive in any person, what-ever his kind of work may be, he becomes an inventive, searching, daring, self-expressing creature. . . . Where those who are not "artists" are trying to close the book, he opens it, shows there are still more pages possible.*
>
> —*Robert Henri,* The Art Spirit

Robert Henri was an American artist and teacher who lived from 1865 to 1929. He sought to validate and empower young American artists as he introduced them to "new" artists such as Degas, Manet, and Goya. What set him apart was his passion for the art that is life and the preciousness of the artist in all of us!

The first step toward acquainting yourself with your artist within is finding its location inside your mind. Your mind is very complex, but everyone is familiar with the right and left brain. We reference these different sides when speaking of different tasks. An accountant, banker, or medical doctor may be more "left-brained" while a decorator, actor, or writer may be more "right brained." Each side of the brain has a different voice. For 90 percent of us, our days are spent tuned in to our left-brain voice. The left brain is closer to our consciousness

because it is responsible for so many of our daily tasks. It is logical, verbal, and analytical. It concerns numbers, statistics, your checkbook balance, "limitations," and "practicalities." We spend most of our days at the mercy of our to-do list. We concern ourselves with deadlines and perimeters. We have a schedule to keep, clients waiting for proposals, and bills to be paid. Every time we think about or engage in any of these activities, our left brain is the voice in our heads to which we must listen. Just as muscles get larger the more they are exercised, imagine your left brain as an overdeveloped, hulking muscle with your itty-bitty little right brain trying to peek out from behind. **To strengthen that right brain "muscle," to give it a voice, we can create a new awareness of the art that is our life and we can use simple, creative exercises to connect to our artist within.**

Just as the Industrial Age gave way to the Information Age, we are in another economical flux. The rules of the game are changing. The world needs new kinds of players, and these players will help to create and carry forward this change.

The creative exercises in this book are going to introduce you to the eight principles of design that artists use to create successful works of art. It is going to give you simple exercises to physiologically strengthen the "muscles" in your brain that will help you to "lift" the ideas off the shelves of your mind and turn them into your reality. When you give your mind new and stimulating tasks it cannot help thinking differently. Once you start to think differently, you will see the actions you need to take. You will gain more confidence in your

abilities. You will take action. It may be no more than a phone call, writing your idea down, joining a networking group, or surfing the internet. Step by step you will make the necessary changes and you will see results! **You will become creatively fit.**

Creativity is breaking out of the box we have put it in, because of the age-old law of supply and demand.

WHY CREATIVE ABILITY IS IMPORTANT

Sociologists and economists are painting a picture of the near future in which creative skills are going to be much more valuable. The demographics of the American work force are changing. Jobs formerly held by U.S. graduates are being outsourced to Asia and India. Task-oriented, information-based careers are being outsourced because other people can do them more cheaply and just as well. If it does not require imagination, if it is skill-based, someone else can do it, and he can do it cheaper. Major corporations are looking to art schools to hire MFA's over MBA's. They need employees sitting around their boardroom tables who can innovate and challenge the status quo. Creativity and design are now all that sets one product or company ahead of or behind another. Just as the Industrial Age gave way to the Information Age, we are in another economical flux. The rules of the game are changing. The world needs new kinds of players, and these players will help to create and carry forward this change.

In the article, "Revenge of the Right Brain," based on his book *A Whole New Mind*, Daniel Pink states:

> *Until recently, the abilities that led to success in school, work, and business were characteristic of the left hemisphere. They were the sorts of linear, logical, analytical talents. . . . Today, those capabilities are still necessary, but they are no longer sufficient. In a world upended by outsourcing, deluged with data, and choked with choices, the abilities that matter most now are closer in spirit to the specialties of the right hemisphere—artistry, empathy, seeing the big picture, and pursuing the transcendent.*

Through the lens of these design principles, bit by bit, brush stroke by brush stroke, your ideas will take form. You will be able to look back and say, "I did it!"

Today creativity is an important skill for everyone, not just for children, artists, or designers. Successful bankers need to be able to paint a picture of a comfortable and blissful retirement for their clients, electronic engineers need their designs to set their products apart from others, civic planners need to help take our communities to new levels and to set new standards, medical professionals need to attract patients based on both the physical and emotional care they will provide, and computer scientists must redefine their role in our national economy. Creativity is breaking out of the box we have put it in, because of the age-old law of supply and demand.

HOW THIS BOOK WILL HELP

In each chapter you will be exposed to a new way of looking at your life and at the world around you. You will unlock your artist within. You will learn what brush strokes, or action, to take; you will learn what colors, or what skills and talents, can be applied to help you reach your goals; you will learn how contrasting shapes, or contrasting daily routines, can enliven your canvas and make it more interesting. At the end of each chapter there is a simple, creative exercise that will illustrate one of the eight principles of design that are used by artists and creative people in every industry, whether they know it or not.

With your new awareness of design, you will be able to create change in your life. The eight principles of design are emphasis, balance, proportion, unity, harmony, contrast, rhythm, and repetition. They are important because of the way your mind's eye sees the world. Through the lens of these design principles, bit by bit, brush stroke by brush stroke, your ideas will take form. You will be able to look back and say, "I did it!"

STEP ONE:

Your Untapped Potential

THE EIGHT PRINCIPLES OF DESIGN

emphasis • balance
proportion • unity • harmony
contrast • rhythm • repetition

The principles of design are not the result of a panel of art academics who felt the need to create more rules. **The principles of design are the language of our mind's eye, how we visually analyze everything we see.** They have been used by artists for centuries to create paintings that successfully communicate their heart's desire, the natural beauty of a landscape, the spirit of a portrait, or the innate element of objects in a still life. Now *you* are going to learn how to use them. The principles of design are interwoven throughout our lives because we process so much of our world and our life visually. As our eye catches the view out the window, the line of cars ahead of us, the expression on a face, the patterns in the fabric, the panels of colors on a stocked book shelf, or the landscape of papers on our desk, our mind is already processing those images according to these principles of design.

For example, whenever you look at anything, your eye goes to the point of greatest contrast. It goes to

19

what stands out the most. Then your eye travels around attempting to find unity within the composition. Unity is pleasing to our mind's eye. The mind wants to feel that everything is integrated, that nothing is out of place or missing. If something is missing we start try-ing to figure out what it is. The way we see things and the way we think about things are intertwined. When we learn this visual language, the interrelation-ship between what we see and what we do, we unleash the artist's potential inside our brain. We can look at our life, our canvas, and identify where we need more or less contrast, pinpoint elements that are in or out of propor-tion, highlight parts of our week that create harmony or daily patterns that injure harmony. Our ability to look at our life in this light resides in our right brain. Our creative voice, our artist within, our muse, our intuition all live there. **If you don't learn to tap your artistic potential you are simply not living to your fullest.**

The way we see things and the way we think about things are intertwined.

The following definitions of the principles of design will help you to recognize the language spoken by your artist within:

EMPHASIS

What is the painting trying to communicate? If that an-swer is clear, there is good emphasis. An artist may use detail to draw our attention to the subject of her paint-ing. From this attention to detail, the viewer can deter-mine what is deemed important. Imagine a group of

faces. If most of the faces lacked detail, but one was painted with eyes that sparkled and rosy cheeks, you would understand that this figure was the most important figure to the artist. **What is most important to you? What are you trying to communicate?** Do the people in your life know what is important to you? Do you make those things a priority or are you apt to lay them aside? Do you have a hard time saying no to the things that take you away from your emphasis? Perhaps being conscious of where you are placing your emphasis will help you to reveal where you need to put more or less of it.

BALANCE

Balance does not always mean symmetry. A painting can illustrate balance when an area of great detail is balanced with an area that is more open and simple, or when an area containing lots of colors is balanced with an area with only one main color. It is the ying that balances the yang. It is the answer to the question. It does not leave you hanging or wondering if something is missing. Good balance in art parallels being well-rounded in life. A workaholic is seldom balanced. If you have a tendency to obsess over an area in your life, thereby neglecting other areas, the principle of balance may serve you well. You may need to take a break and try something new. Get outdoors, take a class, or cook dinner for friends instead of dining alone.

> *Good balance in art parallels being well-rounded in life.*

PROPORTION

Elements in art can be in or out of proportion. Think of Picasso. He painted subjects out of proportion to emphasize or de-emphasize an element. An object may be painted larger than life or smaller, to help the viewer take notice. Objects may be represented in perfect proportion to create a pleasing composition. Think of the *Mona Lisa* or *The Last Supper*. Proportion contributed to making these works legendary. Do you have elements in your life that are in or out of proportion? Maybe there is a part of your life that needs a greater proportion of your time and energy. If you have a big dream, but devote little to no time on it, increasing the proportion of time spent working at it may help you to realize your dream sooner. As you open yourself to a new awareness, keep proportion in mind.

UNITY

A painting that achieves unity usually repeats this or that element. Colors may be repeated, or a particular shape. If a painting does not have unity it may appear disjointed, as though pieces from different puzzles got mixed together. It does not flow. In life, a lack of unity can distract us, make us feel like we are stretched too thin. If you feel this way, try finding the common thread in your life, what is vital. This will help you to refocus your energies and gain a greater unity of purpose. The rule can be applied to teamwork. Finding the common ground, the goal of the organization, can help the team to move forward together.

HARMONY

Harmony is when you get the call that the big client is now yours, that you have received the promotion, that the publisher wants your book, that your child got the lead role, or that you won the day at the spa. It is when spring crocuses emerge from the dirt. It is when you feel like you could run forever at the end of your five-mile jog. It is the "aaaaaahhhhhh" moment. Think of the Impressionist Monet's paintings of water lilies. I have walked the more than twenty-foot length of Monet's lilies in the Museum of Modern Art in New York City. I was in awe. It was harmony embodied. You can feel disharmony in the core of your chest. When you feel anxious or unsettled you are craving harmony. What does that mean for you? Your artist within knows . . .

CONTRAST

What makes a painting dynamic? What gives it depth? What gives just two dimensions their drama? Often it is the element of contrast. Contrast is achieved in various ways. Using light and dark. Using different colors. Using different sizes. Our eye will always go to the point of greatest contrast first. Contrast attracts our attention. It can be used to draw the viewer's eye to the emphasis of a painting. In our lives, a lack of contrast can lead to apathy or boredom. When we add contrast to our lives they become more exciting. Contrast breaks the routine. We learn something new. It gives us something to talk about, to share with our colleagues, friends, and family. It inspires and energizes.

RHYTHM

Everyone has heard of people, especially children, painting to music. Have you ever heard music when looking at a painting? Maybe not, but picture in your mind a painting by Kandinsky. He uses pattern to create rhythm. Objects are repeated in his paintings—the rise and fall of the objects are like a musical tune. Pattern can also be used in our lives to create rhythm. Structuring my weekly schedule provides me with needed rhythm. Each week certain meetings are scheduled, and at certain times each month advertising campaigns go out and artists are contacted. By scheduling these tasks I don't have to spend other time making calls or wondering when to fit them in.

REPETITION

Repetition can be used to draw our attention to part of a work of art. It often works alongside contrast and emphasis to communicate what is really important, and it contributes much to achieving unity. It makes me think of something my grandfather once told me. He said that knowledge breeds confidence. I tend to be a broad-brush-stroke kind of person. For me, repetition means disciplining myself to spend time gaining more knowledge. It means repeating a task over and over until I feel completely confident of my skill. Athletes utilize repetition to train their minds and bodies to perform a task without blemish. Scientists use repetition as an element in their research. When we force ourselves to use repetition, we sharpen the blade, creating the

edge that will set us apart and ensure our success.

THE ART THAT IS YOUR LIFE

You will soon build a new awareness of the art that is your life. Through the creative exercises in this book you will develop the right-brain skills you need to bring your ideas, step by step, out of your mind and into your world. You will strengthen your right-brain muscle, you will become creatively fit, and you will become better equipped to succeed in this changing world. You will feel energized and be able to look at things with a new perspective. When your thoughts are passing through your left brain only, your perspective is limited. When those same thoughts enter your right brain, your perspective is changed—you experience a brainstorm of new ideas and solutions. With each exercise in these pages, your right brain will become stronger. This is how this book will make a difference.

When your thoughts are passing through your left brain only, your perspective is limited. When those same thoughts enter your right brain, your perspective is changed.

MY STORY

When I was the artist, poised in front of the blank canvas, listening for my muse, I was in a direct sales career. I wanted out. I had a new idea. This idea felt different from all the others. It was a vision of a place where anyone could go to make art. It was a creativity "gym," a place to exercise the right brain, a place where anyone could become creatively fit. As I shared my idea, everyone loved it, but how to go from sales to art?

I had not taken an art class since my freshman year of high school. I had always been envious of others' artistic abilities. My artist within whispered to me that I could paint if that was what I wanted. I took a baby step. In my case, it was a trip to the art store. With brushes and canvas, I made my first mark. One brush stroke led to another. I quit my sales job. I visited some local artists. I met a real estate agent with the perfect space for my art center. I cried to my future husband, exclaiming that I was crazy to be leaving the "sure-thing" of my direct sales career, 100 percent commission-based (which turned the tears into laughter!). By then, I had met a carpenter who could furnish the interior free of charge—with colorful pieces of wood he had saved—and I started to feel that this art center was going to happen with or without me. I began to feel pulled along by the progress. I could see that other forces were at work—forces that did not make sense in a left-brain frame of mind. But when I gained access to my right brain, I relaxed and decided to just go with the flow. I continued to paint.

In May of 1996, I opened The Creative Fitness Center. I thought I was offering lessons in art, but what I ended up providing were lessons in life.

At the Creative Fitness Center, I would point out to a student that her composition had too much going on. It was busy, busy everywhere. It needed a quiet place for the eye to rest. And then I would say, "A painting is just like life." And then the student would say, "That is so true." The next week these students would come in and tell me, for example, that they had started hiking again. Hiking provided them with a quiet place. That quiet place had given them the opportunity to take a step back and look at things differently. They had thought of a new idea. They were excited. It became clear to me that this was why I was teaching art. **The lessons I have learned through my experience teaching and making art and those of the people who have passed through my door are what led to this book.** The act of creating with paper, paints, clay, and crayons gave them the skills they needed to create their other ideas. They came into the Creative Fitness Center doubtful or scared, or at least hesitant. They went out inspired and more confident. They started creating change in other areas of their lives. They redecorated; they changed careers; they moved cross-country; they went back to school; they became artists.

For me the Creative Fitness Center was also just the first step. In the beginning, I believed that this was it. I had

arrived. I had found my place. Not so. After eight years I was looking for a business partner. I was tired of be-

I thought I was offering lessons in art, but what I ended up providing were lessons in life.

ing the one-woman show. I now had four children, three of them four and under! The Creative Fitness Center had become known for its youth program and I desperately wanted to work with adults. What to do? I was back in front of the blank canvas, poised and ready, but the next step eluded me. What happened next still blows me away! I found a part-ner (and good friend) just three doors and across the street away. She owned Rumours Gallery, featuring the work of local artists. Many of her artists began to teach classes at the Creative Fitness Center. We began to see a new kind of *unity* that we could create together. We combined her art gallery and my adult classes to cre-ate tHE aRT hOUSE gallery and studio. I left the space where I owned the property and moved into a smaller rental space. Then, the inexplicable happened. My new partner and I opened a Wine Bar! tHE aRT hOUSE and Rumours Wine & Art Bar are located next door to each other and created a way for us to pull people into the gallery and studio. We harnessed the *contrast* principle to create a successful partnership. How much easier to persuade adults to drink wine and eat fabulous food than to take an art class! Now, many of those people who came for the wine stop in next door to take an art class or to buy original art. *Harmony!*

Now, I am a mother and wife, an artist and an art teacher, having just produced my first solo art show, which almost sold out. I am a restaurateur and an entrepreneur. I am on the PTO Board. I have stood in front of the blank canvas and I have admired the painting on the "wall." I am excited each morning because each day brings creative challenges and opportunities. I don't know what it is like to "go through the motions" or experience the monotony of routine. By tapping my right brain, by giving it a voice, I have tapped a bottomless well of energy that fuels me each and every day. It has been more than a decade since I discovered my secret to success; I began to paint, to draw, to collage, to create the ideas in my head. **I began to hear my artist within. Now I want you to hear yours. It lives within the right brain and has been used by people for centuries. It is yours. You already have it. Let's give it a voice.**

YOUR LIFE'S DESIGN DIAGNOSTIC

To get a picture of what your life looks like now, as the artist poised in front of the blank canvas, complete this exercise. Through the principles of design you will be able to see where you may be able to make some shifts or to create some changes in your life and your daily routine. You will be able to see where your life may need some more brush strokes here, more color there, more contrast or unity, more rhythm or harmony. Taking the steps toward making your ideas your reality can be fun, scary, intimidating, exciting, inspiring, daunting, overwhelming, but, ultimately, very, very satisfying. Your life is a canvas, you are the artist, listen to your artist within. After reading the statements to follow, circle the number that comes closest to your typical Monday-through-Friday, or equivalent, routine, according to the designations given here, then tally the numbers circled.

> *Taking the steps toward making your ideas your reality can be fun, scary, intimidating, exciting, inspiring, daunting, overwhelming, but, ultimately, very, very satisfying.*

Not me!	1
Sometimes	2
Not unusual	3
Frequently	4
All the time!	5

EMPHASIS

I do not have too many projects going at one time.

1 2 3 4 5

If someone asked, I could list the three things most important to me.

1 2 3 4 5

If I don't understand something, I make sure I get the information I need.

1 2 3 4 5

I have written down or spoken to others about my personal goals.

1 2 3 4 5

My schedule and habits are tidy and orderly.

1 2 3 4 5

TOTAL:_____

BALANCE

I perform many different tasks on a daily basis.

1 2 3 4 5

I do something nice for myself each day.

1 2 3 4 5

I have many friends.

1 2 3 4 5

I have good mental and physical energy through-out the day.

1 2 3 4 5

I consider myself to be well-rounded in mind, body, and spirit.

1 2 3 4 5

TOTAL:_____

PROPORTION

I understand what feeling a sense of peace means.

 1 2 3 4 5

I plan ahead for personal days, trips, or retreats.

 1 2 3 4 5

I protect my time.

 1 2 3 4 5

I seldom get pulled into obligations I would not choose for myself.

 1 2 3 4 5

I am self-disciplined.

 1 2 3 4 5

TOTAL:_____

UNITY

I feel supported by my friends and peers.

 1 2 3 4 5

I feel open to sharing ideas, thoughts, or emotions with my spouse, partner, or friends.

 1 2 3 4 5

I understand my strengths and weaknesses.

 1 2 3 4 5

I truly love my work environment.

 1 2 3 4 5

I truly love my home environment.

 1 2 3 4 5

TOTAL:_____

HARMONY

If life is compared to a canoe trip, then I am floating with the current.

 1 2 3 4 5

I often talk to or greet people I do not know.

 1 2 3 4 5

I feel connected with my peers.

 1 2 3 4 5

I include others in my plans and free time.

 1 2 3 4 5

I feel like my life will provide for me in the long run.

 1 2 3 4 5

TOTAL:_____

CONTRAST

I am never bored.

 1 2 3 4 5

I can be spontaneous.

 1 2 3 4 5

I am often interested in new things.

 1 2 3 4 5

I consider myself to be generous.

 1 2 3 4 5

I love to spend time alone.

 1 2 3 4 5

TOTAL:_____

RHYTHM

I keep a weekly schedule of personal events, appointments, and so forth.

 1 2 3 4 5

I am usually on time and do not feel rushed.

 1 2 3 4 5

I am able to finish what I start.

 1 2 3 4 5

I have an easy time saying "no."

 1 2 3 4 5

My home decor is a reflection of me.

 1 2 3 4 5

TOTAL:_____

R.E.P.E.T.I.T.I.O.N

I consider myself a confident person.

 1 2 3 4 5

I keep a budget and stick to it.

 1 2 3 4 5

If at first I don't succeed, I try again.

 1 2 3 4 5

I am consistent.

 1 2 3 4 5

I am able to focus on the task at hand until it is completed.

 1 2 3 4 5

TOTAL:_____

YOUR SCORE:

_____	_____	_____	_____
Emphasis	Balance	Proportion	Unity
_____	_____	_____	_____
Harmony	Contrast	Rhythm	Repetition

In each design area, if you scored:

20-25	Great!
15-19	Pay attention to this area.
10-14	Create some change in this area.
Under 10	Get professional help! *(smile)*
	Seriously, do an exercise in this chapter regularly and take the quiz again in one month.

If your total score was in the range of:

175-200	You are listening to your artist within! Keep up the dialogue.
150-174	This book will be great for you! You are on your way to being creatively fit. Get excited to create some change in your life!
125-149	Set the goal to do Creative Exercises each week, but don't reprimand yourself if you miss a day or two. Just do it!
Under 125	Don't feel bad. You are on the brink of something really fabulous, as long as you don't succumb to doubt. Enlist friends to help hold you accountable and keep reading!

STEP TWO:

The World of Things You Make

GIVING VOICE TO YOUR MUSE

I want you to mark up this chapter. Write on the pages. Scribble in the margins. Putting pen, pencil, or marker to paper is the first step to identifying and releasing your ideas. Don't overthink anything. Write down your first impressions. This will give your inner artist a voice. If you do not engage the right brain by giving it something to do, you will not hear this voice. The Creativity Exercises in this chapter are simple and can be done right in the book. Try these exercises. You will begin to see how the way we see things and the way we do things are intertwined. There is a world of possibility inside your mind.

You will begin to see how the way we see things and the way we do things are intertwined. There is a world of possibility inside your mind.

Before there were two worlds. The world of everything "out there," and the "you" that saw that world through the window of your eyes. Now there are three worlds. The world out there, the world "in here," and the world of things you make.

—Peter London, No More Secondhand Art

At times, the world of things "out there" can become overwhelming, frustrating, exhausting, and restrictive. It is also very left-brained. It is full of things that we have to

do. All of these factors can leave the second world of "us" wondering, searching, and hoping. This new third world of things we make is without limits. It gives us an escape. In this world we are rejuvenated and inspired. **This is where the artist within lives.** We begin building foundations in our imagination that lead to change in our first and second worlds. For me, over the years, it has been a respite from the stressful world of entrepreneurship and an escape from all-consuming motherhood. "The world of things you make" is the place that leaves me with the hope for another, better tomorrow.

It is not a difficult trip to make. It requires no previous experience. All you need is five minutes, some crayons, markers, or pencils, and paper. Art and creativity are the tickets to this third world. It changes the way you are thinking and leaves you with a whole new world of possibility. Do you ever wake up uninspired and dreading the predictable pattern of the day that lies ahead of you? Let's explore what itty-bitty changes you could make.

What could you change today about your routine?

Do you get tired of going through the same motions, always wondering somewhere, in the back of your mind,

if there is something else out there? Where could you go this weekend to explore and learn something more about one of your interests? A museum? A seminar? A weekend trip?

Do you get nervous that you have missed the proverbial "boat" and the true purpose for your life?

What name would the "boat" have as it pulled up to your dock? "SS Here's Your Dream Job"? "SS Here's Your Dream Partner"? "SS Here's Where You Can Make a Difference"?

Would feelings of hopefulness, optimism, and excitement be a refreshing break from your status quo?

Many people have a personal mantra that they repeat to themselves to block out the negative self-talk. One that I have used is: "Successful people do the things that other people are not willing to do." Not too snap-

py, but it worked! My latest one comes from a song written by a good friend: "Every day is a sacred day."

Make one up for yourself, summoning your inner songwriter:

The "world of things you make" is up to you! You are the artist. This is what the artist spirit can do for you. Meditate on these words from Robert Henri, author of *The Art Spirit*:

> There are moments in our lives, there are moments in a day, when we seem to go beyond the usual. Such are the moments of our greatest happiness. Such are the moments of our greatest wisdom. If one could but recall his vision by some sort of sign. It was in this hope that the arts were invented. Sign-posts on the way to what may be. Sign-posts toward greater knowledge.

I want to help you create a side of your life where there are no rules, no limitations, and no critics.

This is what it means to be creatively fit. I want to help you create a side of your life where there are no rules, no limitations, and no critics, even if that side of your life surfaces for only five minutes at a time. No matter what the rest of your life looks like, you can add another dimension to it! We start off with

simple art supplies, the principles of design, and Creative Exercises. Then you become so familiar with creating art from pieces of paper and simple art supplies that you find yourself creating new opportunities, ideas, and events from the material of your life. When you learn how to create unity in an exercise using color or shapes, you will also learn how to create unity in your life. I will also suggest projects for those of you who want to **take it a step further.** Some of you may just read this book. That is O.K. You will learn about a whole new world and a whole new well of potential that is within you. You will see things differently as you drive down the road or as you sit in a meeting or as you reason with your child. Even just this awareness will create change in you and in your life.

When you learn how to create unity in an exercise using color or shapes, you will also learn how to create unity in your life.

There are no deadlines or requirements. Do each Creativity Workout at your own pace—even if you can only take part of a workout and spend some time with the colors and the shapes and the materials. These first three exercises are easy and can be done right now in this book. The first one, "Drawing Is Energy" is easy enough for a two-year-old. What it will do for you, first and foremost, is illustrate the mental shift that can take place from left to right brain when you do a creative activity. These exercises are so simple you might be tempted to skip them, but don't. Make your mark—it is a step forward. Try them and you will see.

**Design
Principle:
Rhythm**

YOUR IDEAS:
OUT OF YOUR HEAD AND ONTO PAPER

DRAWING IS ENERGY
See Yourself on Paper

We must accept that this creative pulse within us is God's creative pulse itself.
—Joseph Chilton Pearce

In her book *Art Is a Way of Knowing*, Pat Allen writes, "Drawing is energy made visible." When a roomful of people do this exercise and cover their paper with marks, not pictures or drawings, every single paper has its own personality. Some people doodle curlicues, spirals, and circles. Others naturally draw zigzags, lines, and triangles. I usually doodle curvy shapes, lots of circles, and amoebic shapes. My husband, on the other hand, makes geometric marks using lines, distinct edges, shapes with corners, and more symmetry. We all have our own rhythm. It is when we try to dance to another rhythm, someone else's or one we have imposed on ourselves or each other that we get stuck. Below is our working definition of "rhythm" to refresh your memory.

RHYTHM
Everyone has heard of people, especially children, painting to music. Have you ever heard music when looking at a painting? Maybe not, but picture in your mind a painting by Kandinsky. He uses pattern to create rhythm. Objects are repeated in his paintings—the rise and fall of the objects are like

a musical tune. Pattern can also be used in our lives to create rhythm. Structuring my weekly schedule provides me with needed rhythm. Each week certain meetings are scheduled, and at certain times each month advertising campaigns go out and artists are contacted. By scheduling these tasks I don't have to spend other time making calls or wondering when to fit them in.

When my husband and I were meeting with the landscape architect before our backyard renovation I caught myself saying "curves." "I want the walks and the beds to curve. I don't want hard corners." Hmmm. I landscape the same way I doodle! The truth is, we all make marks differently, in ways unique to ourselves, just as we all approach the same problem from different angles, or dance "to the beat of a different drummer." Our marks are another language, spoken only by us. Shapes and images mean something to us, and conceiving of them is different from one person to the next. Let me prove it to you.

List the following shapes in order, from your most favorite to your least favorite:

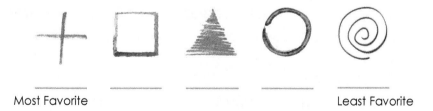

Most Favorite Least Favorite

These shapes are the Five Universal Symbols. If you have young children, you can watch their drawings progress

through these shapes. Their scribbles include the spiral and circle first. Next, the triangle (as a dress) appears below a circular head. The stick figure person they eventually try to create is represented here by the plus sign. Finally, a house may be drawn, as a square with a triangle on top. These symbols have been reproduced by humans from the beginning on cave walls, sheets of papyrus, and stone tablets. These shapes have also been assigned a symbolic meaning. Before we look at that, what do they mean to you? What words come to mind when you think of these different shapes? What do they symbolize to you?

Circle_____

Square_____

Plus sign_____

Spiral_____

Triangle_____

Here is what Angeles Arrien from the book *Signs of Life: Five Shapes Found in All Art and How to Use Them* writes that these shapes symbolize:

Circle: Unity
Square: Foundation/Earth Energy/Grounding
Triangle: Goal Oriented/Reaching the top
Plus Sign: Relationships (East v. West/Night v. Day)
Spiral: Go with the flow

On page 50 (because I don't want you to peek before you list your shapes in order) you can learn the significance of the order in which you listed your favorite to least favorite shapes. If you have already listed your shapes in order of most favorite to least favorite, skip to the end to see the results. So fun!

Don't preoccupy yourself with having to find the deep significance behind every one of these workouts. Just be aware. The more you develop your creativity, and learn to listen to the artist within, the more you will find that you become aware of the world around you. The color of the sky, the way the leaves frame your view, the colors you put on in the morning, the lighting in your office, the art on your walls, the art in museums—you will notice all of these things, and more, and wonder where they were before!

One day, at nap time, my daughter threw a fit! She was yelling, screaming, and refusing to lie down. After several attempts to calm her, I offered to get her some paper and a pen. That brought a quivering end to the crying. I made the simple delivery of some computer paper and a ballpoint pen and left her alone. Ten min-

utes later she quietly emerged from her room, peeked around the corner, and whispered to me, "Come see my art show." She had created three drawings and I

could tell immediately which one she had drawn first. It was the drawing of a girl surrounded by erratic, jumbled scribbles, big eyes with long, straight lashes, a triangle dress, and a heart drawn in the middle. The next drawing was related to the first, but with no jagged lines, and the last drawing depicted two dogs enjoying some dog bones. The most thrilling part was that my daughter was smiling, beaming with pride, and happy! What a relief. The act of drawing had helped her find her rhythm. She then asked me if it would be O.K. if she rested a bit before she drew some more, and proceeded to lie down, head on pillow, eyes closed! It felt like a miracle, but then so simple.

When I had suggested to her that she might rather draw than throw a tantrum, I was thinking, "Let's try to get her in her right brain and see what happens." But the result still amazed me. It was almost instant (since kids express exactly what they feel, it took no time for

her to make the shift as she started making her marks). There are many times that we might choose to draw rather than choose to be frustrated or hopeless or discouraged. If you want to change your energy, or the energy of those around you (remember this, parents of teens!), bring out the paper and pens and make marks.

MAKE YOUR MARK...

Creativity Workout
DRAWING IS ENERGY

Workout

• Place your pen or pencil on the paper. Look at your watch and give yourself 5 minutes. Five minutes is really important. It may start to feel like a long time. **Resist the urge to stop before time is up— that is your left brain talking.** Once you keep doodling past your initial urge to stop, your right brain can really begin to kick in.
• Start to make your marks.
• Fill a piece of paper with any kind of marks. Lines: straight, curvy, jagged. Shapes: all sizes, all kinds. Let one build off the other. Keep going until your 5 minutes are up.

Supplies

• The space provided in this book or any kind of paper.
• Any kind of writing tool. Whatever you can grab right now. Ballpoint pen, pencil, crayon, and so forth.

Can you identify how you were feeling before the workout?

Did you want to stop doodling before time was up?

How are your thoughts different after the workout?

49

Do you see a rhythm in your doodles? Did you reach the point when one mark led to another, without too much thought? We tend to want to force things, to control our surroundings and the people around us. Sometimes, loosening our grip and letting each part of our lives and the people around us find their own rhythm will bring us closer to what we want. Imagine each activity in your day as a mark on the paper. Is there rhythm?

Here is the key to your universal symbol survey. Whichever symbol you listed first, your favorite, symbolizes *your goal right now*. Your second favorite symbolizes *your hidden strength*. Your third favorite symbolizes *what you want your goal to be*. Your fourth favorite symbolizes *what you are considering ignoring*. Your least favorite symbolizes *what you are unconsciously ignoring*.

Sometimes, loosening our grip and letting each part of our lives and the people around us find their own rhythm will bring us closer to what we want.

Whenever I do this with a group, they get so enthusiastic. They understand that their minds each speak a visual language. There is a reason we are attracted to different shapes over others. It is part of our personality. Embracing this knowledge opens a new door to innovative ideas, inspiration, wisdom, and opportunity, inside your mind.

SCRIBBLE DRAWING
The Answers Are Inside!

What lies behind us and what lies before us are tiny matters, compared to what lies within us. —Ralph Waldo Emerson

"Four-year-olds scribble. Adults don't scribble." This is your left brain talking. By doing exactly what your left brain, or logical side, doesn't want to do, you will activate your right-brain, imaginative side, and your artist within. "It doesn't make sense, it isn't logical—must be for me!" This is your right brain, your artist within, talking. Once it speaks up, pay attention. It is providing valuable *contrast* to your left brain.

CONTRAST

What makes a painting dynamic? What gives it depth? What gives just two dimensions their drama? Often it is the element of contrast. Contrast is achieved in various ways. Using light and dark. Using different colors. Using different sizes. Our eye will always go to the point of greatest contrast first. Contrast attracts our attention. It can be used to draw the viewer's eye to the emphasis of a painting. In our lives, a lack of contrast can lead to apathy or boredom. When we add contrast to our lives they become more exciting. Contrast breaks the routine. We learn something new. It gives us something to talk about, to share with our colleagues, friends, and family. It inspires and energizes.

Design Principle: Contrast

Answers to your problems have been backlogged in your right brain waiting for the gate to open. When I am teaching my Painting Made Easy workshop, I always ask my students to imagine those old telephone switchboards. Can you picture the operators sitting in

front of the big board, connecting each line to the appropriate number? Well, imagine your brain having those same operators. Whenever you are participating in a left-brain activity, your left-brain operator is working, and she is really busy. You can just hear her, "Hold, please. Hold, please. Hold, please." She can barely keep up. Your right-brain operator, however, is kicking back in her chair, filing her nails, whistling a tune, daydreaming. We need to give her something to do! Once she plugs in a line, your right brain will open up the line of communication between your consciousness and your artist within.

When I am teaching, I am instantly aware of when the left-brain operator goes on break and the right-brain operator starts to work. The class gets much quieter. The bantering back and forth about the "lack of talent" or "my sister got all the creative genes" ceases. Students are not looking side to side to check their progress against their neighbors'. They are focused, quiet, and content. I think to myself, "Aaaaah, their inner artist has taken over. Nice."

"It doesn't make sense, it isn't logical—must be for me!" This is your right brain, your artist within, talking.

Your artist within has a plethora of ideas for you, new ways to approach the elements of your life, new perspectives, people you should call, a new direction to take, or a hobby you should pursue. There is knowledge in your right brain that is just as valuable, in its own way, as left-brain knowledge. We all need any help we can

get, wouldn't you agree? **So, let's connect to your right brain. It is easy. Simply give it something to do.** Pick up a pen or pencil and start scribbling in the space provided. Scribble for 5 minutes, the *full* five minutes. It is tempting to cut the time short, so tell your left brain to take a well-deserved rest while you keep scribbling!

MAKE YOUR MARK...

Creativity Workout
SCRIBBLE DRAWING

Workout

• This is a "quick" scribble, but try to move your pen all around the paper. Vary the speed and the shape of your scribbles. There may be a slow, arching pen stroke along with some short, jagged ones.

• Put your drawing tool on the paper.

• Close your eyes and scribble for about 5 seconds.

• Open your eyes. What do you see? Add something to your scribble. An eye for a person, long ears for an animal, wheels for a car, lines to finish off the house. Spend 5 minutes adding to your scribbles, bringing shapes or objects out. It is just like lying back and looking at the clouds.

• Make a list of all the thoughts that come to you as you scribble. What did you see in the scribbles? Don't edit your thoughts. No matter how silly, or random, write them down! Why do you see what you see? Pretend your artist within is sending you a cryptic message. What does a man with a large nose and glasses have to do with your life right now? Is the answer right in front of you, so close you have overlooked it? Do you need to spend more time learning, studying? Your scribbles have started a dialogue inside your mind that never would have begun otherwise.

Supplies

• The space in this book or any kind of paper.

• Any kind of drawing tool.

What if your manager, half way through a brainstorm session, asked you to pull out your sketchbook and crayons? After you and your co-workers closed your eyes and scribbled, your manager then asked you to pass your paper to the person next to you, look for the hidden picture or object in the scribbling, and write down all the ways it related to your latest business challenge. Would the presence of crayons in the boardroom throw you off a bit? It would certainly *contrast* with the routine. Would this exercise appeal to your logical or to your imaginative, creative side? Might you get some solutions that would not have been raised otherwise? How would everyone feel, leaving that meeting? Ho-hum? Or laughing, smiling, comparing scribbles?

Would you like to hold a conversation for longer than two minutes with your son or daughter? What if you sat next to them and started scribbling and sharing what you saw in your scribbles? You could ask them what they saw in your scribbles. They might look at you askance because you have not colored with them since kindergarten, but keep scribbling. Their curiosity will get the best of them. Maybe they would like to try their own scribble drawing. Start a sketchbook with your children. Imagine fifty pages, front and back, of your child's scribbles and lists of what they see in them. Ten, twenty years later, those sketchbooks will be an invaluable keepsake!

It can be hard to keep the lines of communication open with your children, or to come up with the knock-

'em-dead business proposal. By getting creative and approaching these problems from a different angle, in *contrast* with our ordinary approach, it is possible to find something we haven't seen before—just as we do in our scribbles!

Next time you are at the grocery store, pick up a sketchbook for your Creativity Workouts. What a great way to journal your creative journey! You may end up with lots of "Scribble Drawings" or "Energy Drawings" in your creative journal.

> *Images and symbols are closer to our subconscious than words are!*

Relating your scribbles and markings to things going on in your life right now can prove to be an interesting exercise. Images and symbols are closer to our subconscious than words are! The images that you create in your scribbles should move you closer to resolving a problem or question in your life. Just looking at your marks will connect your consciousness to your right brain. Your artist within will be able to communicate its perspective. A scribble drawing is a good example of that old saying, "A picture is worth a thousand words."

My first entry in my own creative journal came about as a result of the sudden death of a precious woman who taught at the Creative Fitness Center. News of her death really threw me into a horrible mood that had not lifted days later. I felt like there was no hope, no point; everything seemed useless. I was in my left brain. Finally, I thought of the art journaling class being taught at the Creative Fitness Center. I figured it was worth a shot,

and probably something I should be doing anyway. I sat down with some colored pencils, chose a beautiful red-purple, and started trying to draw a sketchy portrait of Gwendolyn. I did not seem to be able to do her face justice and I kept thinking about the view from my hike that morning. I didn't know what it had to do with Gwendolyn, but I started drawing it anyway. I scribbled the trees and the fields and the leaves, and the sky. Then, I looked at it. It seemed to be missing something. It needed some color. I picked up that same red-purple pencil and scribbled a cloud. Then, I added another shade of purple into the cloud. Suddenly, it hit me! Gwendolyn was the cloud! She was not gone! She was with me, and everyone else who loved her, hovering over us, watching us, shading us. Once I made the shift to right-brain thinking, I realized that what had thrown me into such a tailspin was that she had died in California and her funeral service was held in her home state of Michigan—she had left and never returned home, to Nashville. I will always miss Gwendolyn, but I gained such a sense of peace after the significance of my emotions was revealed to me through my drawings. The last thing Gwendolyn would have wanted was for me to feel hopeless or useless. That experience left me convinced that everyone needed to know about the expressive power of using art to journal their lives! The transformation I experienced was instantaneous after I interpreted the meaning of that red-purple cloud from the perspective of my artist within!

I have experienced that same kind of transformation on other days after an uninspiring morning of folding laundry

and cleaning house, after a misunderstanding with my husband, or after an unsettling dream. I have learned that at those times, I simply need to paint or draw. Instead of internalizing negative feelings, I work them out—creatively. I paint to work myself out of my funk, to get a new perspective on my life, to forget about everything else for a while. Do you know what? It always works!

My husband has a painting of mine hanging in his office that I titled "Bad Bank Day." Visibly, it has nothing to do with a bank, or even money, but he knows why I painted it and what it did for me. I had been overwhelmed and frustrated, so I painted. I picked out an image of ancient sculpture from an art history book and reinvented it on my canvas in full color. As I focused on the lines, shapes, and color, my "bank emotions" melted away. The three primitive figures took me back to a simpler place and reminded me of principles that are bigger than any bank or bottom line!

go to:
www.creativelyfit.com
to see "Bad Bank Day"

Your scribbles, drawings, paintings don't have to make sense, or look like anything, or hang on anyone's wall. Sometimes their significance does not surface until much later. Art is a way to take the information, those feelings that are buzzing around in your brain, and channel them into a different kind of energy, a creative energy. It is an energy that leaves you feeling refreshed, rather than stifled and hopeless. Reach for your pen and a piece of paper now. Close your eyes and scribble again. Now what do you see?

Design Principle: Proportion

PERSONAL SYMBOL
Draw Strength from Within

The fun of living is that we have to make ourselves, after all.

—Robert Henri

We are surrounded by symbols in our daily lives. Symbols are there to tell us when to stop, where to enter, whether to go up or down, what state a car is from, where to eat, which team to root for, and on and on. By identifying favorite shapes and symbols we can gain insight into why we do things the way we do. Like a favorite recipe that calls for less salt than sugar, you have different proportions of talents, interests, and emotions in your personality. You have an exclusive on you. You were created to make a mark on this planet as only you can. Any further insight into the geography of you can only result in a greater personal power that you can harness to create the change you want to see in your world. As you dabble with this exercise, your personal symbol will begin to reveal your strengths and other matters of importance to you.

PROPORTION
Elements in art can be in or out of proportion. Think of Picasso. He painted subjects out of proportion to emphasize or de-emphasize an element. An object may be painted larger than life or smaller, to

help the viewer take notice. Objects may be represented in perfect proportion to create a pleasing composition. Think of the *Mona Lisa* or *The Last Supper*. Proportion contributed to making these works legendary. Do you have elements in your life that are in or out of proportion? Maybe there is a part of your life that needs a greater proportion of your time and energy. If you have a big dream, but devote little to no time on it, increasing the proportion of time spent working at it may help you to realize your dream sooner. As you open yourself to a new awareness, keep proportion in mind.

Symbols have been used by the human race, since creation, to communicate, to worship, to protect, and to identify cultures or tribes. Navaho Indians repeated their personal symbol in the blankets, pottery, and other objects they made. We see such designs as decoration, but for the Navaho the symbolic designs were a reminder of who they were, of their strengths and their talents. The "designs" were given to children by their elders to give them insight into their individual talents and gifts and to give them confidence. By creating our own personal symbol, we will witness another way in which creativity and art can touch a part of our lives that we might not have anticipated.

Remember, images and symbols can speak to our right brain better than words can. Images and symbols can trigger thoughts and ideas that would not have been released otherwise. Involve your environment, the images you see each day, and your surroundings in your

life. Realize the influence symbols and images have on us and use your surroundings to further your dreams and goals! Think of it as creating your personal logo. Just like a business logo, this symbol will serve to summarize who you are or illustrate an idea of what is important to you.

Recognizing the proportions in our own personalities can help us to capitalize on our strengths and to know when to ask for help.

The following five shapes have been referred to as the Five Universal Symbols. We learned about them in the Drawing Is Energy Workout. Read the meanings behind each of these symbols. We will use a combination of them to create our own personal symbol. For you, some symbols are going to speak more loudly than others. We are each cut from different cloth, but the pattern that is created when we work together is what makes life beautiful. Each of us is given different proportions of strengths and weaknesses, talents and interests. Recognizing the proportions in our own personalities can help us to capitalize on our strengths and to know when to ask for help.

It is the proportions that each of us are given that allow us to function as a group. Fortunately, not everyone wants to make a living the same way or shop for the same merchandise. How could we all function as a world if no one liked accounting or if no one liked to work with children, or if no one wanted to practice medicine? We are part of a delicate and miraculous balance that has kept the human race alive on earth

for thousands of years. You are part of this masterpiece and you have been given your own specific talents, gifts, interests, and knowledge. Let this exercise remind you of your strengths, and your weaknesses.

The five universal symbols are very simple. They may not catch your attention at first, but go along with it. If the meaning of a symbol doesn't seem to fit, don't worry about that. Your symbol may have a hidden message for you that you wouldn't have guessed! You may also start to see different kinds of symbols around your work or home. Are the photographs you display predominantly taken in the outdoors? with groups of friends? with families? These can all be symbols as well. Look again at the symbolism behind the simple shapes.

<div align="center">

SQUARE
earth energy, grounding, security, stability
</div>

<div align="center">

TRIANGLE
goals, reaching the summit, goal-oriented
</div>

<div align="center">

SPIRAL
the "go with the flow" attitude
</div>

<div align="center">

CIRCLE
unity, connectedness
</div>

<div align="center">

PLUS SIGN
relationships between people, objects
</div>

MAKE YOUR MARK...

Creativity Workout
PERSONAL SYMBOL

Workout

• First, pick one of the five symbols listed here that you identify with the most. You might know that one of your strongest qualities is that you are a great friend, listener, and are very involved socially—you might first pick the circle. Or, maybe you know that a dominating trait of yours is your ability to get things done; you are always setting goals for yourself—you might choose the triangle.

• Next, pick a second symbol that resonates with you. Maybe there is not just one that really stands out. It might take two of these symbols, rather than one, to describe your dominant trait or gift.

• Pretend you are just doodling on your paper. Pretend you are on hold on the telephone, or think back to one of those boring college lectures. Doodle these two symbols in different combinations and arrangements. You may en-large one of them and repeat the other, like a pattern, inside of it. You may use combinations of your two symbols to create another image or symbol. Think of all the different ways these two shapes can interact. Remember, there is no wrong answer!

• Even if you are just reading this, and not doodling, this workout can get you thinking about your dominant trait, gift, personality. Maybe there is another shape that in your opinion better represents your ability to "go with the flow" than the spiral shape does. For example, a wave shape may symbolize the "go with the flow" trait better to you than the spiral. Maybe the triangle has turned into a mountain for you. If another shape comes

into your mind that you feel more accurately describes you, use it!

• What color or colors would you associate with that shape and the feeling it gives you? If you have them handy, take your colored pencils, markers, or crayons, and scribble blobs of red, orange, green, turquoise, blue, purple, white, and black on your paper. List next to each color what it makes you think of, what feelings you associate with each color. If you have to, close your eyes and picture yourself in a room surrounded just by that color. How would you feel if you spent an hour in that room? What color of room would you most like to spend time in? Use your answers to these exercises to pick some colors for your personal "logo." Then, combine those colors with your shapes, either the ones listed or another shape you have devised.

Supplies

• The space in this book (or other paper), pencil, or pen.
• Colored crayons, markers, or pencils.

Look at the shapes in your symbol. These are all insights into yourself! Maybe you are realizing that what you consider your dominant trait, gift, or personality is not what other people see on a day-to-day basis. What can you do about that? Give yourself more of a chance to exercise your special interests or talents! Pay attention to proportion in your life. Devote more of your time to nurturing that skill or interest. Maybe it means picking up an old hobby, volunteering, or just spending more time with friends. How much of

our time and energy can get sucked into maintaining the house, the job, the needs of those around us? Although all of these things are important, they are not reason enough to sacrifice spending time with who we really are or want to be. We have to spend our time proportionately, not forgetting to pay attention to the things we love and the things we love to do. If you are a "go with the flow" person, but your time has been so structured and full lately, schedule a Saturday afternoon or an evening for yourself, leave everyone else behind, and see what happens.

We have to spend our time proportionately, not forgetting to pay attention to the things we love and the things we love to do.

Does a music event or a garden walk listed in the paper catch your eye? Do you bump into an old friend at the coffee shop? Do you finally grab your watercolors and go sit in the park on your biggest, most colorful blanket and just paint? Get the picture? This is one way your personal symbol has already helped you!

What can you do this week to exercise your special interests or talents?

A Promise to Yourself

Following is a promise you can make to yourself. It is a promise to believe in, to imagine, and to create the life of your dreams!

Believe this . . .

I, _____, promise to believe in myself and in my ability to create change.

I, _____, promise to slowly, but surely, silence the little voice inside my brain that says "I can't" or "I'm not good enough."

I, _____, promise to see creative opportunity around me and in others. Recognizing this creative spirit is crucial for my well-being as well as that of my community.

Signed this _____ day of _____,

year_____.

STEP THREE:

The Creativity Exercises

Exercises in EMPHASIS

EMPHASIS (im-fa-sis)

What is the painting trying to communicate? If that answer is clear, there is good emphasis. An artist may use detail to draw our attention to the subject of his painting. From this attention to detail, the viewer can determine what is deemed important. Imagine a group of faces. If most of the faces lacked detail, but one was painted with eyes that sparkled and rosy cheeks, you would understand that this figure was the most important figure to the artist. **What is most important to you? What are you trying to communicate?** Do the people in your life know what is important to you? Do you make those things a priority or are you apt to lay them aside? Do you have a hard time saying no to the things that take you away from your emphasis? Perhaps being conscious of where you are placing your emphasis will help you to reveal where you need to put more or less of it.

Design Principle: Emphasis

1 TORN PAPER FACE
YOU HAVE THE POTENTIAL

*Life is a work of art, designed by the
one who lives it.*
 —*proverb found inside a candy wrapper*

We have all seen images of primitive African masks—masks carved from wood and used by people living in tribal villages. Why did these cultures spend so much time and place so much emphasis on creating these masks? Think about how much time it would take to make a carved, wooden mask right now. You would have to go out and find wood (even if this meant just a trip to Home Depot), gather your wood-carving tools, and start chiseling away at the wood. The next step would be to sand the wood until smooth and stain parts of it to create contrast in your design. Now imagine life in a remote, African village. The same project would require cutting down a tree or finding some dead wood, using handmade tools to prepare and carve the wood, and obtaining dyes from nuts and berries in order to stain the mask. These tasks might require the better part of a season just to create one mask. Maybe this was your entire role in your tribe, to create masks. In other words, these masks were important to these people. But why?

These masks, people believed, brought them power, good fortune, and strength. I would say that their beliefs were justified. A visual symbol holds the power of suggestion. Images that we look at often, because they make

us happy, because they trigger a positive memory, or because they inspire us, send our brains a message. Our brains register that this image must be important to us. (We will learn how to use these images to get closer to turning our dreams into our reality in the chapter on Dream Collage.) We consciously, or unconsciously, take the steps and notice the details needed to make these images become our reality. When people carved masks to protect them from bad weather, to bring them strength in battle, to give them the swiftness of a gazelle, or the endurance of an elephant, that is exactly what those masks did! They spent hours and days and weeks carving the face of a gazelle, choreographing a dance that suggested the movements of a gazelle, and telling stories of the fabled gazelle. They were emphatic about this discipline. It was very important and demanded much of their time and energy. When it came to battle there were those warriors who moved with extraordinary quickness because they were still imagining that gazelle. Masks were powerful because the emphasis they placed on those masks helped them to believe that they could create change in their situation by adopting the characteristics of the animals and images these masks represented.

If you were going to make a mask, what powers would you want it to bring you? I led a group of elementary students through this exercise. We talked about life in an African tribe. Then, we talked about how our lives are different, yet similar. We still have needs. We don't have to worry about a neighboring tribe attacking us, but we

do have worries. I asked them what powers or skills they would need to overcome what bothered them and what kind of masks they would need to encourage those qualities. They created "Homework" masks, "Getting-along-with-my-sister" masks, and "Basketball" masks. Their needs were different from those of primitive tribal cultures, but now they understood the significance of the masks in the encyclopedias.

Artists seldom know what their finished artwork is going to look like when they begin.

You may want a wisdom mask, to bring you understanding and insight into your situation. You may want a happiness mask, to bring you optimism and good will. You may want a mask with large eyes so that you can really see, a mask with a large mouth to give you a voice, a mask that is beautiful to give you the confidence to assert yourself, or a Mother Nature mask to give you a green thumb. Think about a personal quality. It may be one you admire in others or one that you would like to nurture in yourself. Or, if you could be a super hero, what powers would you want to have? List the kinds of masks you would like to have.

Don't overthink the mask. In redoing this workout, I found that as I put different papers together, different ideas came to me about what kind of mask I was creating. For instance, I just worked on one that had a page from an old math

book as the background, a piece of gold vellum paper for the head, and, for a hat or hair (not sure which), an image of a headboard that looked like it came out of a bedroom in a medieval monastery with gold metalwork and a Christian cross. As I reassembled the papers and images into a mask, it spoke to me of the balance between science and spirit. Take a mental break during your day, just 60 seconds, and imagine what kind of mask you would want to make. By just thinking about the mask, you are changing the way you think and approaching your strengths and weaknesses from a different perspective. In your family or in your organization at work, who wears what masks? Do you need someone to wear a different mask or someone with the right skills to fill a mask? I recently accepted the chairperson position for the decorating committee of a large diabetes fund-raiser. When first asked, I told them "@#$% no!" Then, the ideas started coming in spite of myself and I realized that as long as I had the right team around me I would be able to lend my strengths to the event without having too many irons in the fire. It is under these conditions that I accepted. I was very clear about what I was willing to bring to the table and what I would count on the executive team to provide. I clarified the role I could realistically play and where I would need their support. Now everyone is happy and I have a creative project!

This workout is very fun. Try it. Sit in front of the TV with some old magazines and just start tearing out interesting images and patterns. Stash them in a folder and next time start cutting out eyes, a head, hair. One step will lead to another. Just start.

following is an illu... ...his case. Take the equation

... = 0. Add to b... ...)² = 6¼, and rearrange terms.

...en—

$... - 2(2\tfrac{1}{2})x + (...$...$= -\tfrac{1}{4} = (-1)\tfrac{1}{4}$

...re r... ...2½)... ...quare root of

...ha... ...b... ...by the letter

...the r... ...o r... of the quadratic

...$- 2\tfrac{1}{2}$

...her v... ...have roots of

...$a +$... ...uantities.

...ater ...aning of them.

...adra... ...r fractions with

...s (+... ...

...for...

...tuden... ...by the...method the solutions :

...

...of the

...Thus :

...

...to th pr... ...

...$- ($...

...or...tic equa... ...ean-

...s such as $a +$... ...d is later

...QUADRA... ...LL

...on that... ...o be the

of two factors... ...) and... $= a$, $x = b$

root... ...tic equation... of the form

$... + a^2 =$... ...al root, $x = a$

Creativity Workout
TORN PAPER FACE

Supplies

- Journal, stiff board, side of a corrugated box, poster board, and so forth.
- Newspaper, receipts, food labels, wrappers, magazines, fabric, and so forth.
- Scissors, glue.
- Markers, paints, crayons, or pastels.

Workout

- Choose your foundation paper.
- I start this exercise by tearing favorite pages out of a magazine and pulling out my scrap artwork. I recently found some paint splatters perfect for eyeballs. For the next mask, I used tissue paper with a circular design for eyes. Artists seldom know what their finished artwork is going to look like when they begin.
- Cover your foundation paper with large pieces of paper, fabric, or newspaper. This is an easy first step. I like to divide a larger board (the side of a box for example) into 6"-x-5" sections. Then, cut out sections the same size from magazines, old books, sheet music, junk mail, or newspapers.
- Start with the eyes. Which papers would you like to use? Fabric can be great. Make the eyes *big*. You can always trim them down.
- Next, create a mouth, nose, and ears.
- Glue your eyes, nose, and mouth to paper. Be aware of contrast. If parts do not stand out, make them stand out. On one face I created, I had to switch from blue eyelashes to yellow because the background was also blue.
- Add hair (if any), ears, and the rest.
- How far will you go with detail? You can add paint, create a border, add details of every kind.
- Repeat, like a quilt. One option that is fun is to make at least 4 of these faces and glue them together onto a canvas or board.

Taking It a Step Further...
PORTRAIT COLLAGE

This is another of my favorite projects. It is very simple and easy, but the results are dramatic! There is a template in the back of the book for all the pieces of your portrait. This is so easy! I have led all ages through this exercise, and adults love it even more than the kids. This is a great exercise to do with friends. Invite them over Friday night. Supplies are easy to get. Do it the first time with colored construction paper, then consider experimenting.

Supplies

- Black construction paper (the heavier the better), 11" x 17" or larger.
- Four different colors of colored construction paper.
- Soft pastels (the chalky kind).
- White tempera paint (acrylic is fine).
- Scissors and glue.

Workout

- Pick one color of construction paper for your background.
- On another color, draw your eyes, nose, and mouth. (Refer to template in back of book.)
- On a different color, draw your head (with neck).
- Next, on a different color, draw your shirt and hair.
- Now, decorate these papers with the pastels and white paint. Start with the background paper. Dip the pastel in the paint and draw a pattern. See how the paint and pastel work together? Switch colors of pastels and draw different patterns until that sheet is covered.
- Using the same technique above, create your design on the shirt and hair. Will the hair be spiral shaped, curly, or straight?
- For eyes, mouth, nose, and head, outline first and then add color.
- Cut out eyes, nose, mouth, hair, shirt, and head.
- Glue the head to the black paper. Next, eyes, mouth, nose, hair, shirt.

• Now, cut your background paper into strips to cover the background. At the edge of the portrait, cut the strips so that a little black shows up as an outline around it. We are not going for perfection, just fun!

• Voila! If you want to fix the pastel so it does not smear, use some hairspray or spray fixative. Hairspray is cheaper and works just as well.

How fun is that? Now, **at your next business retreat,** start the meeting with this exercise and display the results together for the rest of the meeting or back at your place of business. Corral the whole family around the kitchen table Saturday night (not the TV) and see how much fun you have! Create a series and frame the collages in a big frame. The results will look as though they belong in a gallery.

SUMMARY

These exercises help us to admit that we all need help sometimes. Where do we want to put more emphasis? The African masks were important because the people who made them knew they needed help. Images that catch your eye, even when you are just leafing through a magazine, are significant because your artist within is communicating to you through them. Simply looking at these images and imagining what kind of mask you might make can provide valuable insight from your right brain. Use this exercise to identify where you would like help. Now, stay open to the help. It will come.

Where would you like help right now?

Design
Principle:
Emphasis

2 LEAF RUBBINGS
CREATIVITY IS NATURAL

*All the arts we practice are apprenticeship.
The big art is our life.* —M. C. Richards

We see thousands of leaves every day but seldom does their significance reach our conscious mind. One of the results of working out your creativity is that you will start to *see things* new and different. This workout becomes a meditation on the simple leaf. The ordinary becomes extraordinary. While we can take them for granted, placing emphasis on an element so common can bring new inspiration. Each leaf is a little miracle. This sense of wonderment and appreciation comes from your artist within and it is part of being creatively fit.

Imagine your neighborhood without leaves—as a desert. Leaves provide us with some of the oxygen we breathe. They shade us from the sun. We love to park our cars under leaves in the summer to keep cool. We do have to rake them up in the fall and they clog our gutters, but when they start peeping out from the branches in the spring we are all filled with that mysterious spring fever. My two girls are in kindergarten and first grade and much of the curriculum this time of year revolves around leaves. The leaves mark the seasons for us and point us back to nature. What are other little miracles that we take for granted? What about light? What about the fact that we can drive down the street and choose from kiwis from Australia and avocados

from California. How do the crocuses know to start growing and how do monarch butterflies migrate thousands of miles? We are surrounded by little miracles. Our artist within loves miracles. Miracles can't logically be explained, so they don't fit into our left-brain world. With an increased awareness of the miracles around us you can be sure that your artist within will help you to create more little miracles in your life. Sound crazy? That is your left brain talking. Let's give your right brain something to do.

This workout is simple and you may be tempted to skip it. Many of us created leaf rubbings as children. This is all the more reason to go outside, plan a hike or at least a walk, and hunt for leaves worth rubbing! Just the "leaf hunt," in and of itself, will give your inner artist a voice. Let this workout serve as your meditation. The simpler the creative task we give our right brain, the easier it is to get to that meditative place. Still yourself long enough to rub a of leaves and connect to your artist within.

Creativity Workout

LEAF RUBBING

Supplies

- Leaves. Big, small. Spring, summer, or fall. If you can use this as an excuse to take a nice walk, do it. Otherwise, just run outside.
- Crayons, soft pastels, or oil pastels.
- Paper, any paper. Computer, grocery bags.

Workout

- Select either crayons or pastels, soft or oil.
- Place the paper over the leaf, and rub the imprint of the leaf onto it with your drawing instrument. Layer the colors. Look at all the different colors in the leaf you collected. If you started with orange, layer some red on just part of your leaf rubbing. If you started with green, layer some yellow or blue.
- Switch papers. Make rubbings on newspaper, construction paper, graph paper.
- Create a rubbing or two each day. Sit in front of the TV and make more. Stick one in your journal and write about leaves. Imagine a world with no leaves. Think about the relationship of leaves to the paper.
- Make a leaf garland. Poke holes in your leaves with a pencil or large needle, and thread string through. Hang the garland over your front door or your kitchen window. Create a fairy woodland in your bathroom. I remember taking a ride through a theme park forest and wondering why we do not decorate our living spaces more like those of the park designers!

One weekend I did this workout with my family. My husband, 16-year-old, 6-year-old, 4-year-old, and 2-year-old all sat down at the table on the screened porch. It was also one of those heavenly fall days, seventy degrees and every tree an amazing shade of gold and copper. The weather notwithstanding, I was feeling stressed. I felt a ball of anxiety in my chest and was hoping that everyone would cooperate and follow directions so that I could keep my wits together. This feeling also gave me the conviction that we needed to create some leaf rubbings. I needed to change my mood, and quick.

The girls collected leaves in an old gift bag and we sat down with a box of crayons and some computer paper. We were all soon busy scribbling and rubbing with the crayons. I marveled at the reaction of everyone to the leaf patterns magically appearing on the paper. We exchanged favorite leaves and suggested different color combinations. My 16-year-old then suggested we make a real tree from all of our leaves. My husband found some scrap plywood in the basement and I pulled out the glue. Everyone chipped in, scribbling brown, black, and red for the trunk. We planned to hang our completed tree creation on the porch!

How did I feel after my creativity workout? The stress ball was gone. I can't encourage you enough to remember to exercise your creativity when you are feeling stressed, frustrated, apathetic, or depressed. It truly works.

The exercise also placed my emphasis on my family and the beautiful fall scenery all around us. It took the emphasis off my problems. **Every day we can choose where to place our emphasis and what to ignore.** Chances are any problem you are facing can be solved with the proper emphasis appropriately applied.

In business, you may have a division or a department that is not performing up to your expectations. At home, maybe your child's grades are down or they don't seem as happy as they once did when they come home from school. Maybe you have gained 5 pounds over the holidays or lost touch with old friends. By placing your emphasis on whatever area in your life needs some change you are ensuring that something different will happen. It is when we ignore or deny a problem or task that it gets sticky. **Go right to the sticky stuff and take action.** You will set the ball in motion and the momentum will carry you forward.

By placing your emphasis on whatever area in your life needs some change you are ensuring that something different will happen.

These days I have to be constantly aware of where I am directing my emphasis. Today I am directing it to this book. I have a big meeting coming up with a publisher and I need time to write, time that I have not taken in weeks. I asked my husband to take the kids with him to the farm today so that I could retreat to the library. What a gift. I am thinking that tonight the emphasis is going to have to be on him!

At work, Christy and I have two very different businesses operating side-by-side that both need our attention. The wine bar will dominate one week because of the inevitable issues that arise managing employees, the wine inventory, the kitchen equipment, and food suppliers. Then, tHE aRT hOUSE calls to us with its own demands, the upcoming art opening, the next art class schedule, keeping the studio supplies stocked, replanting the pots on the patio, approving ads, returning calls, answering e-mails—many are familiar with the routine. Inevitably, problems arise because we have not been placing enough emphasis in one place or another. We are constantly reorganizing our schedule so that we allocate proper emphasis to each department before a problem arises. When one does arise, our immediate attention to it is what is important. It can be so tempting to ignore the uncomfortable areas of business. If we avoid or put off dealing with the situation, we think, maybe it will just go away. Wishful thinking.

Other days, the kids need my emphasis, my attention. I need to take the time to treat them to a trip to the zoo, even though there are a million things to do at home and at work. Once there, the to-do list in my head will be replaced by the monkeys in the trees and the elephants at the watering hole. We can learn to appreciate each moment, to give all of our attention to it, and to do right away what we know needs to be done.

What needs your attention? To what would you like to pay more attention? Write them down and see what happens when you place your emphasis on these parts of your life.

SUMMARY

The principles of design are a terrific way to help us diagnose what we need in our lives or how we can approach life from a different angle. Looking at something as simple as the leaves above us with new eyes is a mental workout. This same approach can lead to new ideas in any part of your life. File the principle of _emphasis_ away in the back of your mind, and it will come to mind when you need it. When an area of your life needs more emphasis, give emphasis a try and you will see a difference!

Exercises in BALANCE

BALANCE

Balance does not always mean symmetry. A painting can illustrate balance when an area of great detail is balanced with an area that is more open and simple, or when an area containing lots of colors is balanced with an area with only one main color. It is the ying that balances the yang. It is the answer to the question. It does not leave you hanging or wondering if something is missing. Good balance in art parallels being well-rounded in life. A workaholic is seldom balanced. If you have a tendency to obsess over an area in your life, thereby neglecting other areas, the principle of balance may serve you well. You may need to take a break and try something new. Get outdoors, take a class, or cook dinner for friends instead of dining alone.

3 JOB–IDEAL JOB ANALOGS WHAT DO YOU LOVE?

It's kind of fun to do the impossible.
—Walt Disney

Design Principle: Balance

I first learned about analog drawing from Betty Edward's book *Drawing on the Artist Within*. She recommends analog drawings as a good starter or warm-up. Analog drawings are non-representational drawings that communicate a person, place, or thing. They are lines, squiggles, dots, and shapes. No pictures are involved. You don't even have to be able to draw a straight line! Because there is no pressure to draw something realistically, analog drawings are a great way to balance your right and left brain, drawing a relationship between words and images. Since the scribbles and squiggles don't "mean" anything to our left-brain voice, it is another simple task we can give to our right brain. Once connected, your right brain (your artist within) will have an idea it has been wishing to share with you.

Can you imagine what Walt Disney's left-brain voice said to him when he first envisioned Disneyland? Walt must have had to dig deep into his right-brain voice, spend time with it, validate it and empower it, to keep moving toward his vision. You need to do the same if you are going to create change in your "land."

After my daughter threw her temper tantrum about taking a nap and was given paper and pen in an at-

tempt to change her thinking, her first drawing had lots of scribbles and jagged lines. Her subsequent drawings did not have those lines and were much cleaner and simpler. Her artwork reflected her mood. When I looked at the drawings, it was very easy to tell which drawing had come first. Those jagged lines and hard scribbles were her way of communicating how badly she felt. That is analog drawing. The act of drawing had also brought her back into *balance*. She was content and restful when she finished her drawings. When you want to feel content and restful, try the following exercises.

Grab any old sheet of paper and fold it into six sections. You can also use the space provided in this book. In each section write one of these emotions: happy, sad, angry, peaceful, frustrated, and lonely. Now draw lines and shapes that communicate each of those emotions. For me, happy always has circular, soft lines and angry has jagged, hard lines. Lonely might be one dot over in the corner and a group of other shapes in the opposite corner.

Another good exercise is turning on music and drawing to the music. Drawing to heavy metal is going to look very different from drawing to a classical symphony. Turn on your radio and hit the first station button. Draw lines that match the music you hear. Spend only a minute or two with this song. Then, press the next button. Keep a pad of paper next to the phone so that when you are on hold and listening to the recorded music, you can doodle. Your analog drawing may be

titled "Waiting on hold for the insurance company" or "Waiting on hold for the computer tech." The operator on the other end will wonder how you are able to be so nice and relaxed.

This can be a great exercise for helping you to relax or to recover from an undesirable mood or situation. Did you just have to deal with a frustrating call to the bank or a disgruntled family member? Did you just pick up the mail and find only bills? Fold a piece of paper into four or six sections and turn on the radio, or write down some of the feelings you have at the moment and draw analogs. How do you feel 5 minutes later? Do it now. Seriously, it can't hurt. On the next page write down two feelings or turn on the radio and hit the search button twice and try your hand at it. It is so easy and it works. You are physiologically changing the way you are thinking to gain a different perspective on your situation. It is how the mind works. It has nothing to do with your drawing ability.

You are physiologically changing the way you are thinking to gain a different perspective on your situation.

Cherish your own emotions and never undervalue them.
 —Robert Henri

Creativity Workout
IDEAL JOB ANALOGS

Supplies

- This book, your sketchbook, computer paper, newsprint—anything you can mark on.
- Any kind of drawing instrument.

Workout

- Choose your foundation paper.
- Divide your paper into six sections.
- In each section write down a quality that would describe your ideal job. It could be as vague as "rewarding" or as specific as "travel," "working with children," "environmentalism," "mountains."
- Create an analog drawing in each section that communicates to *you* that quality. As you think about what shapes and lines could communicate "travel" or "helping others," your mind is making its shift from left to right. Give it a chance to do so. To get going, start with an easier subject like "happy" or "sad." Give your artist within a chance to contribute.
- That's it!

What are some qualities your ideal job would have?

This section's epigraph is a great mantra to recite to yourself when thinking about any kind of desire to change even a small part of your career or your personal life:

It's kind of fun to do the impossible.
 —Walt Disney

Again, it does not have to be about making radical changes. It can be little things that we do to break the routine, to shake things up, to give us a new perspective. It could be organizing a brown bag lunch at your workplace and bringing in a member of the community that you admire to share his story and insights. It could be planning a night on the town as a surprise for your husband or wife. It could be serving pancakes for dinner or re-painting a room in your home. It may mean surprising your child at school and joining her for lunch. It could be teaching a class at a senior center or volunteering at the children's hospital. Starting with baby steps is a great thing!

What are some small things you could do to change your routine?

What is one fun thing you would like to do this week?

I implore you to take action. Do not discount yourself or your ability to create change in your life and in the lives of those around you. I recently committed to sending notes to people and friends to tell them how much I appreciate them or to thank them for a kindness they showed me. I now carry small note cards with me and have made a point to collect more addresses. This is a small thing, but it makes a difference.

If you have not done so, go back to the space provided and write down your fun thing. Go ahead. You will be glad you did! Six years ago a woman started taking art classes with me. She was stuck in an unsatisfying life and did not even recognize it until she took some action in front of the canvas. Listen to her.

> When I think back to when I first started going to the Creative Fitness Center, it was a time in my life when I was completely stressed out . . . a stressful and unhappy work situation . . . making bad (or no) decisions in so many areas. It seems in retrospect that I had an overall dissatisfaction with my life in general. I think just feeling generally unsatisfied had become so familiar, that feeling that way just seemed "normal" . . . at the time I didn't even realize how unhappy I was . . . I was just "stuck." It seemed that once I started working out my "creative muscle" I was able to see the things I was unhappy with in my life more clearly and was almost magically able to become more of a proactive participant in my life. I changed jobs, started looking for and found more fun and adventure, had better relationships, and created great art! And the changes have just continued all these years. I changed jobs again and landed my "dream job," created an art studio in my home, have traveled, have walls covered with great art, and am simply . . . happy. Thanks Whitney! It's been a fabulous journey! I'm glad to still be on the journey! Who knows what will happen next?! —Lisa

Did you catch that she did not even recognize that she had become complacent in her life? The scales were heavily tilted toward her career. Her other side was being neglected. When she was able to balance the scales, change happened. **Doing art was what brought her life back into balance.** You can do the same.

Next time you are feeling frustrated or apathetic, picture scales in your mind. Are they tilted? What can you do to bring them back into balance? Take a field trip this weekend to see something in your geographic region that you have never seen. It might be a museum, a local park, or a small town nearby. Visit an old friend or spend the day in the library exposing your mind to new ideas. **Your hard-working, practical side is doing you no favors if you are neglecting your inner balance.** Everything will suffer if you do not take action to make the changes you need. Remember, finding your artist within and learning how it speaks to you is about finding new potential. This potential is inside you. It is not something you have to learn or attain as much as it is something you can uncover and encourage. It will come very naturally the more you pay attention. You may have another little voice whispering things like "this is not you" or "it may work for others, but not me." That voice is simply not tuned in to the right-brain, artist within. **Your right brain has the potential. It only needs something to do to enable you to become more creatively fit.**

**Design
Principle:
Balance**

4 ABSTRACT CANVAS
IT CAN'T HURT TO TRY

*I give you so much direction that in the back of
your mind you are thinking, "If this painting stinks,
it is her fault."*
— *Me, during a Painting Made Easy workshop*

One of my biggest missions in life is to get people paint-
ing. I know it is scary, but it really doesn't hurt and you
have absolutely nothing to lose. It is just another cre-
ativity workout and it is so much fun! In the back of
this book there is information about how to order one
of my "Creatively Fit Paint Kits." Right now, as I write,
those kits consist of 19,000 empty vinyl envelopes in the
basement of tHE aRT hOUSE and electronic design files.
I have been envisioning these kits for years and am fi-
nally weeks from holding a finished kit in my hands. I
can't wait to share this idea, in my head for so long,
with the outside world! My wish is that people will use
these kits at home or at work to bring more balance
into their lives. When we paint, our right brain gets
jostled from its daydream and given permission to con-
tribute to our conscious efforts. When we wake up our
artist within we wake up ideas, old and new, that have
been percolating subconsciously. Our right brain gets
fired up to take the floor and its mood is infectious. This
is one reason you should paint.

I teach a class each month called "Painting Made Easy." I lead the students, step-by-step, through a painting exercise. I tell them what to paint, how to paint, and what colors to use. I joke that if they ask me for a particular color I will give them the opposite. They laugh and relax when I tell them that my reasoning for all of these rules is to persuade their left brain to think, "Well, if this painting stinks it is *her* fault!" Recently a young couple took the class as a date. Here is what Lena said:

> *We have since (the class) purchased canvases and acrylic paints and have painted a few paintings on our own. In fact, we talked about painting tonight after work! He's finishing up a baseball glove and I'm working on a portrait of my friend with her cat. The class taught us everything we needed to know to get started! Thanks!*
>
> *Lena*

Her boyfriend wrote about the experience on his blog. Here is what he said:

> *Everything I learned about painting, I learned last week at tHE aRT hOUSE. . . . The focus of the class was the absolute basics, so you cover color mixing and basic brush techniques.*
>
> *Don't think I'm going soft with all this talk of . . . art galleries; I can't stand frou frou any more than the next guy, but, I admit, the painting class*

makes for a great date idea. It's a fun experi-ence, a great ice breaker, and shows off your appreciation for art and your creativity. Not only did I learn the basics of painting, but I also had fun. And walked away with a piece of art.

Mission accomplished! I love seeing people cross over from thinking that they can't paint, can't be creative, can't, can't, can't . . . to what I call the "bug-eye" ex-perience. It is like I can see a whole new world opening up inside their minds. They have discovered their inner artist.

Now that they "can" paint, they think of all the years they have spent telling themselves and others that they can't paint or how their brother or sister inherited all the creative genes. They think, "What else have I been telling myself that I can't do? Maybe I should try!" They get so excited. They leave energized and full of new ideas.

One night in class I had a hip, young engineer who had already talked herself out of any kind of painting suc-cess. I love her story. She arrived to the class late. The class was a private workshop for a group of friends cel-ebrating a birthday. There was talk before she arrived about how she was not too excited about the painting part. When she arrived she was hesitant, but she was not given the option of withdrawing so she took hold of a paintbrush. Her appearance suggested creativ-ity. She was wearing a fabulous outfit with coordinat-

ing tortoise shell accessories—very chic. I tried to give her confidence by complimenting her obvious fashion sense. She shared that she was an engineer and could not make mistakes, even by an inch, in her work. She was not used to this way of thinking. My painting class was totally foreign to her daily mental activities. In the class it is about the experience, about learning something new, about having fun. The results on canvas really don't matter. As it turned out, she had a blast. Here is what she wrote to me days later about the class:

I was honestly dreading it! The only reason I went was because it was Jodi's birthday activity. I am very settled & confident in my assessment of my own personality. I am a planner, a list maker, an engineer (probably to a fault) . . . NOT creative. Things are either right or wrong for me, either black or white. This is why I like math—there are rules you follow, and there is a final answer that is either right or wrong. From a very early age, I can remember being uncomfortable in art class. I was always afraid it would be terrible & it mostly was. You (Whitney) were so encouraging and kept telling me that it was an evolving process. If I hated the color, the shape, etc., I could change it later. That gave me a small amount of confidence to start the process. If I would have been on my own, I'd still be there today trying to figure out where to put the first line. I liked that you helped me choose the colors because I was not confident in my own ability. (Still not

at all but willing to try again . . . maybe). I want to learn more about how to mix great colors—I came up with many shades of ugly brown on my own. Afterwards, I was impressed that I created something on a canvas . . . & lived to see it. I'm not ready to hang it in the middle of the living room, but it was a great experience for me. I do not usually put my vulnerable side out there for all to see & maybe I should more often. Thank you for your encouragement and patience. You helped me to see that creativity is not that big of a deal. Anyone can be creative, maybe even me!

 Thank you, Whitney. Abbay

If you can't make it to one of these classes at tHE aRT hOUSE, get one of the "Creatively Fit Paint Kits" and experience the class in the comfort of your own home. For now, here is another painting opportunity. Look back at your analog drawings and pick a favorite. Or maybe favorite parts—a shape or a design—from several analog drawings.

Creativity Workout
ABSTRACT CANVAS

Supplies

- A canvas from your local art store. I like to work with at least size 11" x 14" or 16" x 20". Bigger can be easier. I promise. Go for the 24" x 30" or a chunky, square canvas. Find one that does not have the staples showing on the side.
- A set of acrylic paints. I love the Galeria line for its economy and quality.
- Long-handled paintbrushes in small, medium, and larger sizes.
- Tissue paper. Any color works great.
- Water container.
- Paint palette. Plastic or disposable plates work great.

Workout

- Squeeze out red, green, and black onto your palette. Next time you do this workout pick your own colors. If I want to end up with a lighter-color painting, I begin with darker colors. Since red and green are opposites on the color wheel, they blend together to make a dark, earthy color.

Opposite (Complementary) Colors
Red—Green Blue—Orange
Yellow—Purple Black—White

- If you mix opposite colors together in approximately even quantities you will get a shade of brown, because, in essence, you are mixing the three primary colors (red, blue, and yellow). The three primaries make brown. If you mix the colors together in uneven quantities, for example a small amount of blue to a large amount of orange, you will get an "earthy" color, in this case an earthy orange.

• Also, these colors contrast with each other the most when they are placed side by side. Artists use opposite colors to attract your eye to the focal point of their subject. Leaf through any art book or go online. You will see opposite colors used in almost all of your favorite paintings. Advertisers use opposite colors as well, to attract the customer's eye.

• Last, mix opposite colors together to create shadow. If you are painting a red apple and want to paint the shaded parts, add a dab of green to the red to create that shade of red. If your apple is part of an arrangement for your "still life" painting, and it rests on a blue table, add a bit of orange to the blue (after you have painted the table blue) to paint the shaded part of the table. When you look at any of Monet's water lily paintings, you can see how he painted so many different shades of green by using red in the mix. I love opposite colors.

• Cover your entire canvas, including the sides, with the colors red, green, and black. Do not clean your brush in between colors. Just dip your brush in one after the other. The only other rule is to use no stripes and no columns—this is too left-brain.

• Using the paint as a glue, attach some pieces of the tissue paper. Stick the paper on wet paint and paint over it. Let it wrinkle, but make sure it is all stuck to the canvas. This will create the illusion of thicker layers of paint and add texture. Cover approximately 3/4 of your canvas with the tissue paper. Put your brush in the water when you are done with this step so that the paint does not dry on the brush (acrylic paint dries quickly).

• While the paint is still wet, use the end of your brush to scratch in some of the lines and shapes from your analog drawing. Pick your favorite and enlarge it so that it fills the canvas and spills over the sides, as though you had enlarged the original analog to slightly bigger than the canvas. Allow this layer to dry. You can use a hair dryer to speed up the drying.

• Add some white paint to your palette. Let it mix a bit with the black, red, and green so that you get lighter shades of the colors you used in the first layer. Paint your analog drawing onto your canvas. Add yellow to your palette and let it mix with the other colors. Again, don't bother to clean your brush in between colors. This will give you colors you never would have thought of. Now, color in the different spaces you have formed with your painted and scratched lines. Put your brush in the water again and let this layer dry.

• Look at the colors in your painting. Are there any you don't like? Once these colors dry, paint over them. Just add a little white to any color you want to use and it should cover the old colors well. For the colors you do like, mix the same color, just lighter or darker, and paint another layer. If your painted lines are thick, paint over them on each side so that they appear thinner. Make sure you can see a little of the layer beneath each time you paint. This will make the painting more interesting.

• For the final layer you are going to use the "dry brush" technique. All this means is that you are going to dip a dry brush into your paints rather than a damp one and put less paint on it. This will allow parts of the layer beneath to show through, giving the painting more depth.

• You can keep going and going with these steps. Think of it as your therapy painting and leave it accessible in your home so that you can add to it, 5 minutes at a time, here and there. The great thing about acrylic paint is that you can keep painting over it. I have many paintings that are number three on the same canvas! The paintings beneath just add texture and depth. There is no finish line or time limit. Don't do that to yourself. **Be aware of any pressure you are putting on yourself to perform.** This

Do you put pressure on yourself to perform when it is not really necessary? Give yourself a break and let yourself be open to learning, making mistakes, and learning from those mistakes. Balance those thoughts that make you doubt yourself with other thoughts that put the situation into perspective.

painting does not really matter, right? Just paint, enjoy the colors and shapes, and stop when you feel you are done. Think of it as meditation, not painting.

Do you put pressure on yourself to perform when it is not really necessary? Give yourself a break and let yourself be open to learning, making mistakes, and learning from those mistakes. Balance those thoughts that make you doubt yourself with other thoughts that put the situation into perspective. Where do you put unnecessary pressure on yourself?

SUMMARY
This creativity workout is about balancing the "I can'ts" with the "I can's." As soon as you paint a large canvas, you have crossed over to the world of "I can do it!" Formerly, you may have felt only a certain kind of person was qualified to paint on a canvas. Now you are part of that club. It is not so scary as you thought it would be. No doubt throughout the painting process you had to balance the two voices inside your head. When you achieve success in any area of your life, chances are you have balanced those same two voices. The more you give voice to your artist within, the more confident you will be in your ability to achieve success in any area of your life.

Send me pictures of your paintings! I want to see them! Tell me about your experience. Were you hard on yourself at first? How did you get beyond that? Go to our website at **creativelyfit.com** to send us your image or to view other readers' paintings. Keep painting!

Exercises in PRoPoRTIoN

PRoPoRTIoN

Elements in art can be in or out of proportion. Think of Picasso. He painted subjects out of proportion to emphasize or de-emphasize an element. An object may be painted larger than life or smaller, to help the viewer take notice. Objects may be represented in perfect proportion to create a pleasing composition. Think of the *Mona Lisa* or *The Last Supper*. Proportion contributed to making these works legendary. Do you have elements in your life that are in or out of proportion? Maybe there is a part of your life that needs a greater proportion of your time and energy. If you have a big dream, but devote little to no time on it, increasing the proportion of time spent working at it may help you to realize your dream sooner. As you open yourself to a new awareness, keep proportion in mind.

5 DREAM COLLAGE SEEING IS BELIEVING

Use your imagination not to scare yourself to death but to inspire yourself to life.

—Adele Brookman

Design Principle: Proportion

When we give our artist within images on which to focus, we bring our dreams that much closer to reality. It is common knowledge that the more time we spend visualizing our dreams, the more likely they are to come true. We increase the probability of reaching our goals if we write them down. I read once of the importance of the first twenty-four hours after you come up with a new idea. If you take action within that time frame, the idea will be more likely to bear fruit. Proportion: It is about giving your dreams the attention they deserve and acting assumptively, as you take small steps toward reaching your goal. Don't listen to your little (or big!) voice that is telling you right now, "It's never going to happen!" Think of how much time you spend doing things you don't want to do, complaining, or worrying. Let's fill more time with positives and optimism and take the time and action needed to feed our vision of how we would like things to be. Let's increase the proportion of time we spend on our dreams and allow images to program our subconscious into getting us there. Remember, we want to get your creative, imaginative side calling the shots, not the practical side.

I was lucky enough to catch Elizabeth Gilbert, author of *Eat Pray Love,* on *Oprah* one day. Elizabeth encouraged those of us who want to live our dream to write at the beginning of each day, "What I really, really really want . . ." She emphasized the significance of the three "really's." That third really sends the message to your subconscious, "Hey, this is important stuff. Stop the presses. Sound the alarm. We've got to make this happen." What I really, really, really want is for Elizabeth Gilbert to read an advance copy of this book and provide a testimony for the back cover! If it is not on there as you hold this book, you can bet I'll be shooting for the second edition! **What is something you really, really, really want right now?**

the more time we spend visualizing our dreams, the more likely they are to come true.

Can you imagine what tomorrow would look like if you were living your dream? Think about it now. This won't take long and I bet you will enjoy it. Where would you wake up in the morning—beside the ocean, in a high-rise downtown . . . ?

Think about when you woke up this morning. What would be different about it if you were living your dream?

What sounds would you hear? Would it be the sounds of the ocean, your horses, the big city rush? Close your eyes now. Take a deep breath, relax your shoulders, unclench your jaw, and let your mind imagine. This is called daydreaming. It is a good thing to do. Are you there now? Come on, close your eyes and just let your imagination start going.

What would be the first item on your agenda? Writing the chapter of your next book at the computer, cooking breakfast for the guests of your B & B, getting out the paints in your studio?

9:00 A.M. _____

11:00 A.M. _____

Lunchtime _____

2:00 P.M. _____

Now that you are in your dream and your imagination is in the driver's seat, think back. What did it take you to get there? Was it finally writing that business plan, simplifying your life, going back to school, making that big move, talking to others who were living your dream?

How I realized my dream!

> Step One
>> Step Two
>>> Step Three

Getting anywhere requires no more than a series of small steps. If we look at the journey as a whole, it can feel overwhelming, but in small steps, it becomes manageable. Let's take just the first step now. You can do this. It is fun and painless and it is a great way to recycle those old magazines that have been accumulating on your table.

Getting anywhere requires no more than a series of small steps.

My dream collages always include a lot of beautiful country vistas. One of my dreams is to own a large piece of land that my family and I can live on, but also offer it as a retreat for people who want to escape city living. We would also incorporate art workshops and creativity training into the package. Another thing I know is that there would be several tree houses scattered around the property with different themes. One might have rocking chairs and books, another finger paints and paper! At this moment, I am typing from

a log cabin near a national recreation area during a weekend retreat. These short get-a-ways into the woods always fuel my imagination and my resolve to find my retreat property. I can picture it all clearer. **I am spending a *proportion* of my time fueling my vision. If I did not, what would be the chances of it happening?** I look at the landscape outside the car window and picture what my land will look like. Is it wooded, flat, rolling, meadows, or a combination of them all? Sitting in our log cabin, I can imagine the log cabin I will build. I notice the warm glow of the sunlight on the honey-colored logs and the smell from last night's fire. When I go home, these memories will feed my imagination as I dream.

(As I am reading this chapter, six years later, my husband and I are owners of 120 acres and a rustic log cabin, located an hour and fifteen minutes from our home! We found the property as a result of my search on the internet for an organic gardening magazine. I just wanted a monthly publication, but one thing led to another and we are now that much closer to our dream of the creative retreat. It has been six years, maybe a little longer than I had originally anticipated, but the land and the cabin are now a reality.)

Look at your calendar. Let's carve out a proportion of your time to spend on your idea. What small step could you take next month to put yourself in an environment that will help your dreams seem closer to reality?

In her book *Visioning*, Lucia Capacchione documents her use of collage to help the people she has worked with to create a clearer picture of what they want their lives to look like. She comments:

> *Visioning is a process for creating the life you want. It is a method for finding the dream that lives in your heart and translating it into the world of three dimensions.*

You may wish to make several dream collages this year. That is fantastic. More than one collage is never a step backward. Think of how you could use dream collages with other people in your life.

Would the dream collage be a great rainy day activity with your child or a friend?

Could you use the dream collage as a tool to get to know the people you manage better or to open a meeting and get new ideas flowing?

Creativity Workout
DREAM COLLAGE

Supplies

- Old magazines, catalogs, or newspapers
- Your journal, a blank page in this book, or the side of a cereal box
- Scissors and glue

Workout

- Cut out any images from the magazines that you'd like to have in your future. Don't try to be too organized about this step. If it looks good, snip it! You can figure out how they all fit together later. You can tear whole pages out and trim them down with your scissors after you are done. If you want to collect the images over time, find a folder or box for storage.
- Remember, do not qualify your images by feasibility, money, or potential obstacles.
- Glue your images onto stiff board or into your journal. The side of a cereal box will work great! This will also encourage you to cover all of the space, unless of course bran flakes fit into your dreams!

- Take an inventory of the images you chose. Are there some recurring themes?
- What small steps can you take this week to get you that much closer? If you had lots of water or ocean images, for example, you may wish to search for water. Try the pool at your gym, or a nearby lake or river! Did your images revolve around a certain career you would love? Is there someone who is in that career now whom you could take out to lunch to pick her brain? Or go to your local library and look up information about any of your dreams. Subscribe to a magazine. Little steps, all put together, will get you wherever you want to go!

• What little steps could you take this week, or this month, to move you closer to realizing your dream?

SUMMARY

These collages are valuable because of the message they send to our brain. They say to our artist within, "Hey, these things are important to me and you need to help me figure out how to get to them in person!" Their purpose is not to decorate your dining room or win any beauty contests. Just get those pictures cut out, glued down, and tacked up somewhere where you can see them regularly. Search out articles and books on the subjects surrounding your dreams and ideas. Feed these inspirations that pop into your mind. It is all about proportion. The greater the time you can spend imagining your dreams, the greater the chance that you will turn those dreams into reality. Oh, and have fun while you are doing it!

Exercises in **UNITY**

UNITY

A painting that achieves unity usually repeats this or that element. Colors may be repeated, or a particular shape. If a painting does not have unity it may appear disjointed, as though pieces from different puzzles got mixed together. It does not flow. In life, a lack of unity can distract us, make us feel like we are stretched too thin. If you feel this way, try finding the common thread in your life, what is vital. This will help you to refocus your energies and gain a greater unity of purpose. The rule can be applied to teamwork. Finding the common ground, the goal of the organization, can help the team to move forward together.

What is vital in your life?

Design Principle: Unity

6 THE OPPORTUNITY TO CREATE IS EVERYWHERE

Why should we all use our creative power . . .?
Because there is nothing that makes people so
generous, joyful, lively, bold and compassionate,
so indifferent to fighting and the accumulation
of objects and money.

—Brenda Ueland

I can't help thinking of family when I think of tree art. It may be my immediate family, my family of friends, my work family, or my school family. Family is the group of people surrounding us in the different spheres of our life. Each of these "families" has both the power to lift us up and carry us through and the power to knock us down, make life difficult, or, even worse, pay us no mind. This also means that in our own lives, in the spheres in which we rotate, we have the ability to be a creative force for good, bad, or indifference. Unity is a design principle that is always relevant in any familial unit.

What are your spheres of influence? your families?

What are the opportunities you have in each of these families to create?

I love the epigraph on the page opposite because it refers to our creative power as not just one that can create beautiful art pieces, but as one that can create beauty anywhere. It also alludes to the belief that if we exploit this creative power, thereby using our right-brain skills, we feel better, more "generous, joyful, lively, bold and compassionate, so indifferent to fighting and the accumulation of objects and money." Have you experienced this right-brain shift? Have you picked up this book and tapped into your creativity to find that when you were done you felt happier and more optimistic than when you started? This is why we need to recognize our creative ability and to call on it when we need resolution, when we need unity, in any kind of situation.

The following poem was written by a woman I met during a women's entrepreneurial group. She is a realtor, but wants to spend more of her time working with children and music. We did not know each other when she wrote this, but you'll see why she gave it to me.

We create Life
We create Happiness
We create Love that surrounds us
We create friendships that will stay and ones
that will go
We create yesterday and tomorrow

We create conflict and hostility
We create peace and tranquillity
We create change and opportunity
But most of all we create our own DESTINY.
—*Suzi Minor*

Our belief in this creative power is tied to our sense of hope. People can only feel hope if they believe that their situation can change or improve. Regardless of our situation, good or bad, we all need to feel hopeful. Hope can be an enormous unifying force. Sometimes we get so bogged down in a situation that we can't see past it. It feels like nothing will ever change. Maybe we feel like we are all alone, as if deserted on an island. No one really cares. No one can help. Maybe your colleague at work feels this way about a current project or your child feels this way and appears withdrawn. This is when we need to tap into our creative power. It is only when we feel empowered to create the change we need that we can feel hopeful and optimistic.

At work, if your team, colleagues, or employees do not feel unified under a common goal you are not going to have an optimistic or hopeful organization. People are the unifying force in any group. Likewise they have the power to create disunity. Once we realize the power each of us has individually to affect the people and families around us, then we can use our lives to create a supportive and creative environment. When I am conscious of living artfully, I approach problems differently.

I have learned a lot from my business partner, Christy. We sometimes have had an employee who is not doing her best work. Instead of pushing that person away, letting her go, or penalizing her somehow, we try to unify ourselves with her. We look for ways to support the employee and thereby create a greater desire on her part to work harder and do her best. Maybe she is experiencing tough times or something is troubling her. The more quickly we can communicate and empathize, the more quickly everyone feels better and work improves. It does not make sense to the left brain. It does not make sense to try to empathize and spend time with someone who is causing you angst. Your right brain, however, wants to create unity. When the angst taps on your shoulder, use these workouts to tap into your right brain. Wake it up. Say "I need your help here."

The Torn Paper Tree workout can be used to create a sense of gratitude, to recognize our place in our respective families, or to think of ourselves as one leaf on the big, old oak tree of life. It can help to put things in perspective or to generate new ideas. All you have to do is to establish your purpose. Are you doing this alone or with a group? Is this a team-building exercise, an exercise in communication, or a way to hold yourself accountable to creating new ideas and exciting change in your life? Write down your purpose for this creativity workout:

Creativity Workout

Supplies

- Your journal or heavier paper (even an old piece of plywood would work well) to use as foundation paper, and grocery bag paper or computer paper for the tree's trunk and branches.
- Fine-tip permanent marker, soft pastels, and a pencil.
- Scrap paper collected from junk mail, ticket stubs, photographs, wrappers, food labels, foil, greeting cards, leaf rubbings, and so forth.
- Craft glue. (Wallpaper adhesive from the hardware store works great too!)

Workout

- Tear leaf shapes from your scrap papers. Tear strips of paper for the trunk and branches.
- With the permanent marker, write words on some of the leaves, or all of the leaves—it's up to you. These words may remind you of your families or of your strengths or of wishes or of things for which you are grateful. These trees can be made greeting-card size or large. What a great card to send to a friend!

- Glue the trunk pieces down first and then the leaves. Layer the leaves, so that they overlap one another. Add some background with contrasting papers. Fill the space.
- If you feel compelled to add paint to your tree, go for it. Paint leaves or just drip the paint onto the paper. Take any of these workouts as far as you wish. Even if you spend only 15 minutes on this workout, that is 15 minutes you have

used meditating on your connection to the people around you! That is extraordinary! Congratulations.

•Look back at your purpose for this workout. If you did not write it down, now write down any thoughts. Give your artist within a chance to contribute.

•That's it!

SUMMARY

Unity in the art that is our life is about finding the common thread that weaves itself throughout. Think about the things that are most important to you. Think about the friends with whom you spend the most time. What shows or movies are your favorites? What are some of your favorite hobbies or activities? You will probably find a common theme as you think about these elements in your life. You may also be made aware of an activity or element that is inconsistent with your "common thread" or think of something else you could do to reinforce the things that are important to you. In any organization you belong to, unity can be created by everyone agreeing to and being made aware daily of the group's goals or mission. Sometimes we simply fail to revisit that unifying principle often enough. Talk about unity the next time you are sitting around the conference table or the dinner table. You may be surprised. If you skipped the Life's Design Diagnostic at the beginning of the book, go there now. Which design principles could help you the most right now? Find out!

7 JUNK DRAWER SCULPTURE CREATING THE EXTRAORDINARY FROM THE ORDINARY

The world of reality has its limits; the world of imagination is boundless. —Jean-Jacques Rousseau

Design Principle: Unity

Everyone has one! It is in your kitchen, your office, or your family room. Is there stuff in there that you probably don't need? Sure there is. Cleaning out a junk drawer can symbolize cleaning all the cobwebs and jetsam out of our minds. As you let go of the half-burnt candles, old paperclips, plastic souvenirs, and matchbooks that have been stuffed into the corners of your junk drawer, you might think of experiences or those awful grudges we all hang on to for far too long! Instead of merely discarding all the old junk, or discounting our past experiences, let's turn this stuff into something else. Perhaps *sculpture!* Just think of it as recycling! We can always take something from our past and apply it to something new. **Even the most seemingly unrelated bits of our lives can find unity when we shift our perspective.**

All our experiences are there for a reason, and there may be a unifying thread running through them. Maybe you have not thought of it that way before. We can spend more time thinking of what we would like to have done differently, or we can look at all those experiences as necessary little pieces that are slowly but surely guiding you to the life of your dreams. **"Momma never said it was going to be easy,"** but if we believe in

the creative process, new opportunities and potential will present themselves to us.

Ask anyone who sculptures, and he will say that one thing builds to another. One step leads to the next. Most artists don't have it all figured out from the start. That is usually unrealistic in any situation. When you look back at the timeline of your life, your childhood, your upbringing, your education, first jobs, first loves—can you see how elements from each of these experiences have led you to where you are today? Below, list your top three memories, starting with your earliest. Don't overthink, just write down the memories as they enter your mind.

Each of these elements has unified itself under the umbrella of you. When it seems that our best-laid plans are going astray our first reaction is to become very frustrated or angry, but **if we are aware of unity in our lives we automatically start to piece together how this turn of events is going to work in our favor.** Unity can come from disunity, can it not? As the artist in our own lives, we have to hold on loosely to our goals and expectations to give them room to evolve as we take one step after another. Artists have to do the same during the creative process.

There are some people who have taken the "junk drawer" concept to new heights by making it their life's work. I recently read a story in Mary Engelbreit's magazine *Home Companion* about Joan Steiner, author of a series of books titled *Look-Alikes.* In her books, Joan displays her creations made out of snack food, kitchen utensils, tools, corks, thimbles, toothbrushes, and much more! She made a house out of old blinds (the siding), birthday candles (front porch railing), wooden kitchen forks (columns), puzzle pieces (stepping stones), and endless other knick-knacks! I read in the magazine: "Philosophy major Joan never studied art. 'I didn't think I had what it took to be a great painter.' Later, 'it dawned on me to try to earn a living at doing what I love—making things.' Those 'things' are 3-D collages in which thermos bottles become rocket ships and flash lights turn into trains. Joan is currently working on her third book and looks very happy, posing with her glue gun!"

Regardless of the outcome, keeping yourself aware of all the creative potential around and within you can only be a good thing.

Joan's story can open your mind to all the possibilities that are out there for us! Joan's journey led her to an entirely new career. For you, it may just lead to a new hobby or a new way of looking at things. Regardless of the outcome, keeping yourself aware of all the creative potential around and within you can only be a good thing. If you would like more inspiration, just type "recycled sculpture" into your computer's search engine and

browse the myriad studios of artists who are creating art out of metal, plastic, machinery, and countless other scrap objects. They are creating unity out of garbage. We can do the same, both literally and figuratively. But first be sure to open your junk drawer to see what is there and think about what you might create with it!

An artist I have recently had the pleasure to meet is Anne Grgich. She is a talented artist and woman who has used her art to help her cope with and work through some dramatic life events. As a nationally recognized "Outsider Artist," she has been featured in books about outsider art. Her art is widely collected and she has been a part of or featured in too many exhibitions and events to count. She uses collage, found objects, paints, wax, charcoal, and almost anything she can get her hands on to explore the "landscape of the mind." This introduction is prelude to more about Anne, following the weekend workshop at tHE aRT hOUSE she is coming in a few weeks to teach . . .

What a gift to spend an afternoon with this artist! Anne Grgich sees art in everything. After six hours with her, everything from tea labels to mustard seeds becomes a potential art element. We painted with coffee grounds mixed with glue, curry powder and glue, magazine clippings, food labels, gold leaf, paints, and pastels. She also creates magnificent art books using big, old art or religious books. She raids used-book stores, the thicker and shinier the paper the better. Then, she starts work

simply by covering a page with the collected items. Sometimes she starts with only black and white, other times she uses a combination of colors. A layer of acrylic medium is added next to make it nice and goopy before she outlines a face in dark paint. After that layer dries more are added. A watered down white paint or gesso is used to define the background or part of the face. Then, color is added with collage and paint. Another layer is created with the coffee or curry mixture, then mustard seeds for texture, and finally, wax. All these different layers come together, unified, to leave us another Anne Grgich work to admire. Lying on the table, all the different ingredients look unrelated. In the end, they are unified by Grgich's inspiration, and the art has unified her. It has given her an activity that she is passionate about and that helps her to make sense of her life and everything around her.

After a car accident in the 1980s, Grgich lost much of her memory. Even while still in the hospital, her art helped her to piece together what had happened and how she was to move forward. Through marriage, divorce, and single motherhood, her art has been the thread, or the rope, that she has held onto to make sense of her world. She is committed to sharing her art with others in hopes that they too will find joy, release, and meaning in their own artistic expression. Go to an-negrgich.com to learn more about this amazing artist.

A common misconception about artists and their art is that they know exactly what they are going to sculp-

ture, paint, or draw when they begin, that they know what the result is going to look like from the beginning. This is *false!* An artist is usually somewhat sure of only that first step. It may be no more than a color, a subject, or a particular object that catches his eye in the junk drawer! After that first step, then and only then does the second step become clear. One step builds on top of another. You might look into your junk drawer and an old battery catches your eye. The metallic shimmer of the battery leads you to a length of wire that has been coiled up in the drawer for years. It would seem that the only way to connect the two is to wrap the wire around the battery. But you stop with some wire left over, spying a pencil the wire could be wrapped around to curl it. Go ahead and string a couple of those random washers on that wire or glue the washers to the battery. Now they are eyes and the wire is hair! See how this works? There is no prescribed course—just like life.

> *An artist is usually somewhat sure of only that first step. It may be no more than a color, a subject, or a particular object that catches one's eye.*

Creativity Workout

JUNK DRAWER SCULPTURE

Supplies

- Your junk drawer.
- Glue gun, white glue, wire, or duct tape—the stickiest you've got!
- Acrylic spray gloss.

Workout

- Pull your drawer all the way out and set it on your kitchen table or counter.
- Look inside your drawer for an object that could be used as a base or just the first step. For example, your sculpture might evolve to be flatter or taller. You might end up using the side of a cereal box and covering it with your junk. Or, you may have an old ruler that you build up and along, like a caterpillar. Or, it could be an incomplete deck of cards that catches your eye and you glue the rest of your objects up from that like a totem pole.
- Pick out the next object. Where does it fit in? Or do you see something else that would fit better?

Use a glue gun, white glue, duct tape, wire, nails—anything, to start creating your sculpture.

- It may evolve into an abstract (representing nothing in particular), or maybe it starts looking like an animal, a person, or another object.
- Don't worry if you don't have time to finish it in one sitting. Leave it out and add to it during the week (when you're on the phone, while you're on hold, for example).
- Stop when you know it is done. Throw it out, keep it, turn it into the gag gift this Christmas, whatever! All that matters is that you did it! Now you can start imag-

ining what to do with all that free space you've cre-
ated in that drawer!

SUMMARY

**Creating the extraordinary from the ordinary is what
this chapter is about.** Looking for unity within the dis-
unity, or for the sculpture within the junk, exercises that
creative muscle in our brain that helps us to create
good from any situation. As the artist in front of your
life's canvas, you can use the design principle of *unity*
to help you select the elements needed to get the pic-
ture you desire.

Exercises in HARMONY

HARMONY

Harmony is when you get the call that the big client is now yours, that you have received the promotion, that the publisher wants your book, that your child got the lead role, or that you won the day at the spa. It is when spring crocuses emerge from the dirt. It is when you feel like you could run forever at the end of your five-mile jog. It is the "aaaaaahhhhhh" moment. Think of the Impressionist Monet's paintings of water lilies. I have walked the more than twenty-foot length of Monet's lilies in the Museum of Modern Art in New York City. I was in awe. It was harmony embodied. You can feel disharmony in the core of your chest. When you feel anxious or unsettled you are craving harmony. What does that mean for you? Your artist within knows . . .

**Design
Principle:
Harmony**

8 COVER A PAGE WITH COLOR USING COLOR TO TAP YOUR SUBCONSCIOUS

The position of the artist is humble. He is essentially a channel. —Piet Mondrian

You have heard of sports teams who paint the visiting team's locker rooms pink. The idea is to lull the other team into such a complacent mood that they are not effective as competitors. In a book I just picked off the shelf at my favorite bookstore, *Color Your Home* (Axis Publishing, 2005, p. 22), Suzy Chiazzari writes that the "inhabitants" of a home with pink are described as "likely to be caring and compassionate to others." Exactly the energy with which you would like to infuse your opposing team! A red front-door on your home is supposed to bring prosperity. Red is also supposed to stimulate the appetite and create an environment in which people feel predisposed to spending money. In the same book, Suzy Chiazzari writes "the red personality is dynamic and sociable, and may find inactivity difficult to endure." I can relate to that description myself. Ever since I opened the Creative Fitness Center I have had a red room in my business or at home!

Regardless of what the experts say, the most exciting part is how color makes you feel. Color can be used to create harmony in your life. Color is another way in which your artist within speaks to you. It is another

language of the right brain. You may not be aware of it yet, but each of us has his own palette. We all notice and are affected by color.

What are the colors of the rooms in your home?

Bedrooms? _____
Kitchen? _____
Living areas? _____
Another room? _____

In the book *Creating Sacred Space with Feng Shui,* Karen Kingston (Broadway Books, 1997, p. 234) shares a quick overview of color personalities: "RED activates and draws attention. BLUE cools and relaxes. GREEN heals and revitalizes. YELLOW enriches the emotions. BROWN is grounding but can be too heavy. PINK is the color of love. ORANGE stimulates hunger."

Trying not to overthink (there is no right or wrong answer), jot down words that you associate with these colors:

Orange_____
Blue _____
Red _____
Green _____
Yellow_____
Purple_____
White _____

How can you use color to create harmony in your life? When I first opened the Creative Fitness Center, I would often retreat to the upstairs studio space solely because it was painted hues of blue and white, colors that invoke peace and tranquillity. I would be worried about the bills to pay, the low class enrollment, or the rusted electric box. I would be experiencing a moment of doubt, a dip in my faith. Something had derailed my "Little Engine That Could." The cool, ocean colors would instantly calm me and give me a greater sense of peace. I would lie down on the Mediterranean-blue carpet, arms outstretched, gazing at the ceiling, and just breathe. **The blue reminded me of ocean waters, the endless sky, and all the possibilities represented by the depth of the sea and the expanse of the heavens. I found harmony within the discord.** I was able to re-enter the busy space downstairs with a shift in perspective, one that gave me a boost of courage to continue to meet the day. I was then able not to take myself so seriously and could believe that it would all work out. I wouldn't end up on the street or in jail and everything would be O.K. All of that from some blue carpet and blue wall paint! Had I not been aware that shades of blue affected me that way, I would have missed out on the boost offered me by that upstairs

I have entered numerous work environments transformed by color, and the people who work in these spaces eight to ten hours every day are bubbling with enthusiasm.

space. I want you to be aware of the colors around you and the colors inside you.

Think about the beginning of your day. When you enter your closet to select your clothing, what do you think about? comfort? your activity for the day? Do you look at the colors? Is it a red day or a beige day? Do you gravitate toward that "power" tie or bright-colored suit on days you want to make an impression or express self-confidence? Think about it tomorrow morning.

I also loved learning that warm tones (oranges, reds, rusts, earthy browns, creams, and the like) in our living spaces flatter our skin tones. Our complexion finds greater harmony surrounded by warm colors than by cool colors. This tid-bit I picked up from a news show covering set designers for popular TV sitcoms. The designers of course choose colors that will flatter the actors and create an appealing canvas for us out in TV land.

Can I speak to the corporate folks for a minute? Please purge your work spaces of the color gray! Why do so many office spaces remind me of a janitor's closet? How can people feel excitement and inspiration in their workplace with prison-inspired color themes? A janitor's closet and a productive, inspiring work environment have very little in common. There are so many examples of dynamic, colorful corporate spaces. These spaces, filled with harmony, promote enthusiasm and optimism in employees. I applaud those of you who

have been brave enough to break from the pack and color your work world. I have entered numerous work environments transformed by color, and the people who work in these spaces eight to ten hours every day are bubbling with enthusiasm. For the rest of you, I implore you, recognize how much we are affected by what we see and what is surrounding us and simply change the color of your walls.

For this creative workout you need only some blank paper and a set of crayons, pastels, or markers. This is a *great* workout to use at work, before a songwriting session, or with your family around the kitchen table. The exercise is to give yourself a chance to do nothing but look at a color for five minutes. After all the thoughts that rush through our brains minute to minute, spending five minutes looking at a color as it appears on your paper in twists and turns, squiggles and dots, is a dramatic shift in your thought processes. Just as our Scribble Drawing and Energy Drawing workouts made possible, you can't help having different thoughts and ideas. Feelings of being overwhelmed, apathetic, hopeless, or plain tired are replaced with new ideas, a new approach, better feelings. Your mind cannot help making the shift from left-brain thinking to right-brain thinking after scribbling color on paper. Your artist within loves color and will start to chatter away if you give her the opportunity. Your artist within has an idea that has been waiting to get out. Let's open up the line of communication with a crayon and a piece of paper. Try it!

MAKE YOUR MARK...

Creativity Workout
COVER A PAGE WITH COLOR

Supplies

- Paper. Any kind. The bigger the better, but computer paper will do.
- Pastels, crayons, or markers.

Workout

- Choose a color. Look at the box of crayons, pastels, paints, or markers. Which color appeals to you the most? If the crayons were candy, which one would you pick to eat? Which color strikes you? Pick up that color. Now, close your eyes, take a deep breath, and try to identify your feelings, what you have just been thinking about, what is on your mind. Write it down if you like (have you started your journal yet?).
- Cover a paper with that color. Remember, this is only about looking at the color for 5 minutes. It does not matter what your marks look like—and I encourage you not to draw anything realistic, just draw lines and shapes. Treat them like footprints or a path. Let one mark lead to another. Don't edit your marks or critique them.
- If you are using paints, change the color value by adding white or black. This will make the color lighter or darker and will add more interest.
- When time is up, close your eyes again and note how you feel. Different? Record how you feel in your journal. Look at your colors again. Which one would you choose now? If you have 5 more minutes, cover another page.

The other day, my eyes fell on some wooden cigar boxes someone had given me long ago. For some reason on that particular day, I was inspired! I am always looking for creative ways to store all my stuff and these boxes were perfect!

Once I realized that paintings can have many layers, I was able to keep painting past my frustration and enjoy my work at the end.

One of the first things I learned when I started painting in 1995 was that most paintings have several layers. Before that, I had been comparing my first layer to my image of the finished product. I would become frustrated and often give up. Once I realized that paintings can have many layers, I was able to keep painting past my frustration and enjoy my work at the end. Before I launch into this Cigar Box project, let me say a few words about painting.

I was never one of those "artistic" people. Growing up, I was always involved in a creative project of one sort or another, but I did not think I could paint or draw anything "acceptable." When I decided to open the Creative Fitness Center and to quit my sales job, I started with some oil pastels, a pad of paper, and an Impressionist art book. I copied a painting of a field of poppies. At first, I was straining to copy each individual poppy. It was tedious. Then, in a flash of understanding, I saw the poppies not as poppies, but as smudges of color arranged in a general pattern. The red and

orange smudges were toward the top of the green and blue smudges! Eureka! I dove in to the paper with new abandon. I proudly displayed the piece on some string with clothespins opening day. Within the month I had sold the piece to a woman who still takes classes with me years later. I never imagined, even when I was in the process of opening the Creative Fitness Center, that I would be hanging my own paintings on the walls. That first sale inspired me and it got me painting! I have come to love painting. I consider it part of my life's work to encourage more people to paint. This cigar box is a great place to start. Starting to paint by covering functional pieces like a box or a chair with your favorite colors is fabulous because they are not as intimidating as a canvas. Just remember not to take yourself too seriously. **If you have not painted before, or in years, don't expect any more from yourself than if you had not run in years and were going out for your first jog.** Just like a muscle, your creative side needs to be exercised regularly to get the results we all envision. Remember, these Creative Workouts are all exercises to get you in shape, and getting in shape takes time. Relax. Enjoy.

Taking It a Step Further...
CIGAR BOX ORGANIZER ART

Supplies

- Get a cigar box or any other small, wood box or frame.
- For your paints, use any kind of acrylic, water-based paint. It could be left-over latex wall paint, craft paint, or artist acrylics.
- Brushes.

Workout

- Just as you picked your first color in the Cover a Page with Color exercise, do that now.
- Paint your entire box. Don't worry about the bottom of the box or the underside of the lid. Recognize that paint can act like glue, so paint thin coats and move the lid to your box so that it is not painted shut.
- Once the first coat is dry, pick another color of paint. This project works best if the second color contrasts with the first color. For example, in doing this exercise just now, my first layer was red and the second layer a light green-blue.
- Now it is time for the second coat. You are going to paint one side at a time because you will be scraping words into the wet paint as you go. You will want to use a brush with a pointed end or have a toothpick or dull pencil nearby for inscribing the paint. Paint the top first, then scrape words into the paint. You will see the base color come through.
- What should I write? The good news is that the goal is to write loosely enough that the words are design elements before they are legible. I would recommend writing short, two-to-three-word, sayings that will make you happy whenever you use your box. I did this project just after hurricanes Katrina and Rita socked the Gulf Coast. Values and principles are

key at such times because that is all some people have left. I wrote "be kind," "love each other," "feel joy," and more on my box. If you are more of a planner, find a favorite quotation or saying first. Honestly, the most fun I had was seeing the red peek through the light green-blue.

• After the box has dried completely, coat it with several layers of clear acrylic spray gloss. Any brand will do. Don't be afraid to apply up to 6 coats! Let each coat dry before applying the next. The high gloss is fun and will make your box look more finished.

SUMMARY

Harmony is about the elements in your life that make you feel you are going with the current. Harmony supports you, makes you feel satisfied and complete. It reinforces your goals and dreams, does not distract or compromise. Anything to the contrary needs to be examined. Even seemingly unrelated activities can be part of your own harmony. Imagine a song in your head. Now imagine a loud twang in the middle of your favorite chorus. That twang is not harmony. If your life were a song, where would the "twangs" be? Work to harmonize those elements in your life. Listen to the artist within. Give your right brain more to do so that your artist within can be heard, so that your creative muscle can get stronger. Small steps, one step at a time, when all put together make a big difference.

Design Principle: Harmony

9 CLAY CHARADES WORK OUT YOUR IMAGINATION

Creativity is . . . seeing something that doesn't exist already. You need to find out how you can bring it into being and that way be a playmate with God.
—Michele Shea

This is a great icebreaker, whether the ice needs to break around the kitchen table or the conference table. If you want to harmonize your group, just pick up some clay at a craft store and lug it to your next meeting. There is something about having your hands in the clay, the earth, that gets the wheels spinning. I had a little boy in an art class once who was very, very quiet. We had been painting before we moved into the clay room. He had not spoken more than five words. As soon as he got his hands in that clay, however, he started grinning ear to ear, bouncing around in his seat and talking a mile a minute. I have seldom witnessed such a dramatic shift, although adults who are working the air bubbles out of their clay run a close second. During the first clay class, I give each person a large hunk of clay. It is always lumpy, so the first task is to make it flat with no air bubbles. The easiest, and most fun way to start the process is by slamming the clay down onto the table with a subtle pull toward you so that the clay stretches out each time it hits the table. Soon, my students are laughing and commenting on

how they have learned everything they need. "This is too much fun! And so much cheaper than therapy." Molding the clay with your hands will definitely change your way of thinking.

Clay Charades is much like Pictionary, except that instead of drawing you are sculpturing. Michelangelo once said that his sculptures appeared to him from within the stone as he worked, rather than his imposing his vision on the stone. He viewed himself as an extension of the stone. His sculptures created harmony from hard stone and chisels. Again, most

If you want to harmonize your group, just pick up some clay at a craft store and lug it to your next meeting.

people assume that artists have "it all figured out from the beginning." Not so. They rely on each small step to reveal to them their next step. Instead of having a set goal (a finished image) in mind, artists may know only the colors they want to use, the stone they want to sculpture, or a subject they wish to explore. They have to loosen up to get what they want. In the arena of life that you inhabit, you are the artist. You may not know how to make it happen, but you know that change is needed. Without jumping all the way to the happy ending, just take a step forward, any step. Read an article, make a phone call, admit that the issue exists, and commit to being open to the change. Let the willingness to be open to change carry you the first leg of the journey.

I was reading the November 2005 issue of O Magazine and in it Dawn Raffel writes about a new approach to

goal setting: don't do it! In the article, "Are Your Goals Holding You Back?" she reports on Stephen Shapiro's new approach at his corporate motivational workshops. He has found that "the most fulfilled people were also the most spontaneous and the least goal oriented." Apparently, if you have too rigid a vision of how your life should be, you may be missing out on subtler signs that are leading you down a different, and ultimately more fruitful, path. I experienced this when I left my old career in direct sales to open an art center, with no art training,

If we stay rigid and unbending, we are going to miss out on opportunities that come our way.

and, most recently, when I opened the wine bar and restaurant. I could not have predicted either of those careers months before they collided with my life, but, in hindsight, it is clear why they did. At first, they did not seem like harmonious moves, but in the end they complemented other aspects of my life perfectly. In order to be able to take advantage of these camouflaged opportunities you must have an open mind and a courageous spirit. You must also have the ability to imagine your life down this new road so that you can do what it takes to start walking down it. For this, you need strong right-brain muscles and creativity.

Try this workout on your own first. The next page has suggestions for how to get going. When you do this with a group, cut up this page, or a photocopy of it, and throw the pieces in a hat. Very few people read-

ing this would claim to have sculpturing abilities right now. Don't worry about that.

Let the clay remind you of your own ability to bend and twist, mold and adapt to the world and situations around you. If we stay rigid and unbending, we are going to miss out on opportunities that come our way. Imagine yourself ten years ago. Could you have predicted your life today? Most of us would say "no." Stay close to the things that bring harmony into your life and hold loosely to the others. You don't want to miss out on opportunities that come your way simply because they do not fit your five-year plan. Remember, by strengthening that right-brain muscle, you can stay open to the twists and turns in your life that may lead you down the road to the life of your dreams.

> *Stay close to the things that bring harmony into your life and hold loosely to the others.*

Creativity Workout
CLAY CHARADES

Supplies

- Any kind of clay: modeling clay, ceramic clay, polymer clay
- Objects written down one by one on pieces of paper.

Workout

- Pick one of the objects listed at right or from your own collection.
- Say you picked "chair." Start to sculpture a chair out of your piece of clay. Continue until you feel satisfied that someone would guess a chair or until someone actually does. Whoever guesses it correctly is the next sculptor.
- Shape your clay into a ball, square, pyramid, leaf, tree, flower, caterpillar, cat, dog, dog bone, chair, book, balloon, fork, spoon . . .

Objects

chair	dog	flower
balloon	ice cream cone	
ant	house	teeth
snake	hamburger	
fish	bear	turtle
shovel	tree	
	present	
car	airplane	apple
butterfly	shoe	

What are some goals that maybe you have been hanging onto too hard?

Can you more loosely define some of your goals? Instead of "Number-one star on a TV show that promotes creativity" (speaking for myself, of course), could it be "Spread the message of personal empowerment through creativity to more people"?

If you really get turned on by the sculpturing bug, explore the possibilities. There are tons of great books on the subject. I would go for the versions geared to youth first. They can be less intimidating and more fun. For Christmas this year, my husband has just given me a large piece of soapstone, some stone sculpturing tools, and a book. I haven't worked with this medium before, but why not? If you want to explore sculpturing with clay, you can start with modeling clay or polymer clay

from the craft store (polymer clay will harden in the oven, but modeling clay stays soft forever). Any place that offers pottery classes can suggest ways to explore sculpturing in ceramic.

SUMMARY

Remember, you are the ultimate sculpture. You are both the sculptor and the sculpture. Your life is like a piece of stone being chipped away, bit by bit, day by day, to reveal its final masterpiece. Shun passivity. This is not for you. Recognize resistance as opportunity for growth. While reading about corporate leadership in *Fortune* magazine this morning, I was not surprised to read that all the contributors agreed that hardship and conflict provided the greatest learning opportunity and the catalyst for true change. Look for harmony in the discord. Follow the words of Michelangelo and let your life's path appear from within. Then, follow the path, taking small steps at first. Follow your instincts and take the time to listen to those instincts by tapping into your right brain. **The only thing to be afraid of is being too fearful to try.**

Exercises in CONTRAST

CONTRAST

What makes a painting dynamic? What gives it depth? What gives just two dimensions their drama? Often it is the element of contrast. Contrast is achieved in various ways. Using light and dark. Using different colors. Using different sizes. Our eye will always go to the point of greatest contrast first. Contrast attracts our attention. It can be used to draw the viewer's eye to the emphasis of a painting. In our lives, a lack of contrast can lead to apathy or boredom. When we add contrast to our lives they become more exciting. Contrast breaks the routine. We learn something new. It gives us something to talk about, to share with our colleagues, friends, and family. It inspires and energizes.

Design Principle: Contrast

10 PAPER WEAVING GETTING BACK THE *WOW!*

Do not fear mistakes—there are none.
—Miles Davis

I have created this project hundreds of times, with all ages. My latest epiphany during a Paper Weaving Workout was that it is all about contrast. The contrast is the "WOW!" It is what makes this exercise fun.

When you bring the element of contrast into your life, you are not cutting productivity from your life, you are complementing it. Your artist within wants you to appreciate your work by making sure you have time to play. It wants your time relaxing to contrast with your intense, stressful moments. Your artist within would argue that you can't have one without the other. Without contrast your life would be wallpaper, the same elements repeating themselves over and over with no variation or break in routine.

The masterpiece you are painting, the masterpiece that is your life, is not wallpaper. It has light areas and dark areas, color and shadow, big things and small details. Without contrast it would not hold the viewers' attention. It would pass in and out of their field of vision without causing even a ripple of interest. It is easy to make sure that your life's canvas catches the eye, holds one's attention, and stimulates new thoughts or ideas, feelings, and emotions. Simply add some contrast.

I have led toddlers and corporate groups through this Paper Weaving exercise. In both cases, before the exercise, both groups are predictable. The toddlers' scribbles are familiar and the corporate adults make jokes about their lack of artistic ability. But when those papers are cut into strips and woven together, they become *fabulous!* Toddlers' weavings are framed and given as gifts and the corporate group huddles around to plan where their masterpiece is going to hang back at headquarters. Something almost magical has happened. We have taken ordinary things (scribbled-on paper) and turned it into something extraordinary. Why is that?

The masterpiece you are painting, the masterpiece that is your life, is not wallpaper. It has light areas and dark areas, color and shadow, big things and small details.

Contrast. When you look at the pieces woven together and how unrelated parts of a design have become intimately attached in the over-under process, it holds your attention. "Look at that red next to that green!" "Look at that dark line peeking in and out, at every other strip, from behind the dusty purple and yellow paint splats!" There is the texture of the woven papers, the subtle shadows cast by one strip on top of another. In the same way, we can create contrast in our lives.

If you spend a lot of time sitting at a desk during the day, go rock climbing in the evening. If you manage people all day long, finding a quiet nook in the library may be a welcome reprieve. We all know a hot bath

can contrast with a busy household or hectic workday beautifully. A woman I got to know at the Creative Fitness Center learned that art helped her to manage her grief.

> Before I started taking classes at tHE aRT hOUSE, I had always considered myself, if not creative, at least crafty. I was a writer at some point in my life, but making a living got in the way. So going to art classes was a little scary—I hadn't done anything creative in at least 5 years. I felt very self-conscious and pressed to perform, but Whitney really took the worry about me out of the situation, and let the taking care of me start. This time last year I was 5 months pregnant. I lost the baby. I found someplace I didn't need to talk with words that let me focus on something other than grief for 2 hours a week. That place was tHE aRT hOUSE. Now I'm even considering writing again. Maybe!
>
> —Amy B.

Amy needed a distraction to be able to better manage her despair at the loss of her baby. She needed an activity that would dramatically contrast with the rest of her daily activity and give her a reprieve from the sadness.

Unless you are a full-time artist, creating with art materials probably contrasts dramatically with how most of your time is spent. Most adults I meet have not touched

art materials in decades. Many once did, but that was before school or kids, or a scarring comment from an art teacher. Amy hadn't painted much, but last year she painted with me for two hours a week. She painted several paintings for her new home and for her husband's office. I am also happy to report that as I type she is home with a newborn baby boy. Not that the creative exercises had anything to do with that, but it is creative and it is a happy ending! It was not always easy for her to carve two hours out of her week, but she knew that doing so was important to her life. She needed that time and the contrast to balance the rest of her time spent at work and with her family. How did you score on the contrast segment of the diagnostic? Think about your day-to-day routine. Let's shake it up a bit.

How would you characterize the way you spend most of your time?

What would be the opposite? the contrast?

What are some things you could do differently to change up your routine or put yourself in a different place?

You are going to create different, or contrasting, designs on two different sheets of paper. To begin, we will use color to create contrast, but once you do this exercise the first time, you will begin to see all the possibilities. I will outline those possibilities at the end of this chapter, but for now, let's talk about color. We are going to use warm and cool colors to create contrast in our paper weaving.

WARM AND COOL COLORS

Warm colors are reds, oranges, golds, rusts, yellows, buttery creams. Cool colors are blues, purples, greens, and grays. Of course, you can always mix colors to create warm blues or greens, or cool reds, but for our purposes in this exercise we will call warm colors red, orange, and yellow, and cool colors will be blue, purple, and green. Warm and cool colors *contrast* with each other.

Creativity Workout
PAPER WEAVING

Supplies

- Two pieces of drawing paper.
- Crayons or oil pastels.
- Watercolors (those obtainable at the grocery store will suffice).
- Brushes.

Workout

- Choose warm colors (red, orange, yellow) from the crayon box.
- Look at the clock; give yourself at least 3 minutes for this first paper.
- Use your non-dominant hand to cover one paper with marks. Press hard so that your lines are dark. This aids the watercolor step to come.
- Scribble all the way to the edge of the paper. Let one mark lead to another (just as in the Creativity Workout #2 Energy Drawing). Draw squiggles, lines, dots, zig-zags. Resist the urge to draw an object. Start by choosing a color and placing it on the paper. Do not lift the crayon from the paper until you decide to switch colors. Pretend you are two years old.
- Cover the next sheet of paper with cool colors (purple, blue, green) in the same manner. Look at the clock. Are 3 minutes up?
- Next, open your watercolors and dab a little water in each pan with your brush. This gets the paint ready for your brush. Cover the warm color paper with the same colors of paint. If you pressed hard enough with the crayon or oil pastel, you will see that the wax or oil resists the paint, giving your paper the batik effect.

171

•Now dab dots of red paint into an area you have already painted yellow. Make sure the yellow paint is still wet. Watch the colors spread on the paper. Layering colors is a good thing. It makes any piece more interesting.

•After you have painted both papers, cut each paper width-wise into 1" strips. Pick 6 from the warm color sheet and 6 from the cool color sheet. Lay the 6 warm strips on the table and weave the cool colors, over and under, through the warm colors. You may remember this procedure from making construction paper placemats in kindergarten.

•To save your weaving, put a dot of glue under the end of each strip.

I lead many corporate groups through this exercise in our studio at tHE aRT hOUSE. They always have a blast. One of the ways they adapt the exercise for their home office has made weekly meetings a lot more fun. Each person brings old memos, pages of research, old notes, newspaper articles, and instruction manuals to cut and weave at the beginning of the meeting. Within five minutes they are able to communicate their frustrations and new ideas, while creating the desktop weavings. The creative energy is flowing, they are all open-minded, and their meetings are unceremoniously productive. How can you adapt this exercise in your daily routine?

HOW TO HAVE MORE FUN LOOKING AT ART

Now that you are aware of the principles of design, opposite colors, focal points, and color families, you can have a lot more fun looking at artwork. Next time you do, look for the layers of color peeking out from behind the dominant final layer. It is this interplay between the contrasting underlayers and the top layer that causes a piece to catch and hold our attention. Upon further examination, what at first appears to be a simple object, reveals layers of color. A red apple is not just red. It has blue and orange and yellow. Those layers are what cause it to hold our interest.

Taking It a Step Further...
HANDCRAFTED PAPER WEAVING

Whenever I see those handcrafted papers hanging from the displays in the art stores, I just want to do something with them—anything! When you select paper for this project, pick your favorites. Then, pick other papers that complement your favorites. Maybe there is another paper that shares the same colors, or the same texture but different colors. There are very thin, transparent papers that are fun to layer over the others. Enjoy yourself. This is a great errand to run.

Supplies

- Handcrafted paper from the art store. Buy at least 3 sheets; 5 will do nicely.
- Scissors and glue.
- Stiff board (mat board, cardboard, and the like).

Workout

- Much like the Textured Abstract workout, you are going to cut and tear half of each piece of paper. Cut and tear contrasting shapes. If you have some smaller, torn pieces, cut some long, thin pieces. If you have geometric shapes, also cut some rounded, curvy shapes. Without thinking too much about it, glue the results into layers on the intact halves of your paper.
- After the glue has dried, cut your papers into strips. Experiment with cutting some strips wider than others, and instead of cutting with scissors, place a straight edge against the paper to tear it in straight lines.

- Weave your pieces together. Make small weavings for little frames and little spaces, or create a meandering woven mural to fit that large space over your sofa.
- **More ideas . . .** With your scraps, cut them into 1" or 2" squares and mount them to blank notecards or greeting cards for your next occasion. Or get a high-gloss decoupage glue, such as Modge Podge, and decoupage them to a papier-mache box you get at the craft stores for a fun storage solution. You can also collage, write, or stamp on papers and then cut those and weave them together.

SUMMARY

Transformation. What was two, flat pieces of paper, now has personality. By simply rearranging the elements and connecting them through weaving, we have transformed two dimensions into three. The paper has become sculptural. **Sometimes, just shaking things up, doing things a little differently, can lead to dramatic results.** Anything that contrasts with your normal routine will catch your attention and the attention of your artist within. This is true in our own lives as well. Taking a different route to work, not going straight home from the office, going to a different section of the bookstore, calling a new acquaintance, having breakfast for dinner—these are all things that can make us more aware and bring out something new. That is good.

**Design
Principle:
Contrast**

11 TORN PAPER ABSTRACT LEARN TO FOLLOW YOUR OWN LEAD

*Life shrinks or expands in proportion to one's
courage.* —Anais Nin

Yesterday my life felt like one of my Torn Paper abstracts. We are just five days into the New Year and what I call "Post Traumatic Holiday Syndrome" seems to be running rampant. It is like we have all just been dropped from an airplane smack back into the center of our lives. The contrast between the special events of the holidays and the routine of everyday life is at its greatest. Getting back into the routine is uncomfortable and there is this nagging feeling that something is supposed to be different. Except that now we are old enough to recognize that things only change if we change them. Then there is this immense feeling of responsibility to do everything we did not do last year, perfect everything we did not perfect last year, hit the goals, learn the dance steps, and so on. It is daunting.

My real-life Torn Paper Abstract included all of these experiences, pasted one on top of another, in a haphazard design. It was all the torn pieces of paper, the scraps, the leftovers. It was the imperfect remnants from the year before, unfinished plans, unforeseen obstacles. On top of that, experience underscored the fact that the world is not perfect, that people will continue to let us down, and that all of our dreams may not come true. This is how I felt yesterday. It was horrible.

You know what my beacon of hope was, my silver lining? A swatch of fabric. Its tangible nature, its harmonious design, and its contrasting colors were an anchor for me. The colors were rich, the texture warm and inviting, and it shimmered in the light. It instantly tweaked my visual side and whispered to me, "You can create whatever you want."

Try to be open to those "somethings," those experiences that bring contrast into your life.

When you create your own Torn Paper Abstract, think about the pieces of your life, your talents and experiences, the people in your life and how they can all work together to create something good. That does not mean that they all always get along or match up perfectly. It is contrast that makes life interesting. We would never say that the same thing day in and day out is what keeps life exciting. Another thing that happens when you paste different papers down next to one another is that the most unlikely combinations complement each other. In the Clay Charades chapter, we entertained the philosophy that true success comes from holding onto our goals loosely. This enables us to ride the current and take advantage of unforeseen opportunities.

There may be something coming into your life that you never would have expected or to which you would normally never give a second thought. Try to be open to those "somethings," those experiences that bring contrast into your life. In the meantime, let's flex those creative, visionary muscles of ours.

Creativity Workout
TORN PAPER ABSTRACT

Supplies

- Stiff paper or board for a base (such as a cereal box).
- Scraps of paper from around the house (wrapping paper, newspaper, magazines, catalogs, construction paper, junk mail, and so on).
- Scissors and glue.
- White acrylic paint or house paint.
- Brush and water.

Workout

- Assemble your scrap paper collection. You can start collecting the scraps ahead of time and storing them in a bag, your journal, or a binder.
- Tear the paper into different shapes. Let some stay bigger and others smaller.
- Cover your stiff piece of base paper with the torn scrap paper randomly. Don't think too much about where the pieces "should" go. Add more torn shapes, randomly. Let glue dry. Cover with acrylic paint. It could be leftover house paint or artist paints. Leave bits and pieces, and abstract shapes showing. Apply paint with a wider brush. At first, let the brush skip over the paper lightly, helping you to see where you would like to completely cover the scraps and where you would like the papers to remain exposed. In the areas that are going to be completely covered with paint, build up the paint with one thick layer or several thinner ones.
- The more you layer the colors, the more exciting the results will be. Let

this project linger over weeks or months. Apply layers once a day, once a week.
• If a shape or an object comes to mind in the process, draw it onto the design. Draw it large and slightly off-center. Then start painting and layering. This project can be done quickly or done at length. Either way is great.
• Look at your finished piece.
• List your thoughts.

Life shrinks or expands in proportion to one's courage.

—Anais Nin

What thoughts are triggered by this quotation?

There is an artist who is the mother of an acquaintance of mine. When I saw a postcard of a piece of her work it was like a bolt of lightning. It had so much energy. My friend, the owner of the postcard, explained to me how the artist layered and layered the paints and other materials. Just when a piece looked perfect she would slap an entire layer of blue or black or orange over it and keep going. It would just get better and better. Most of us want to stop the process. We want to leave good enough alone, for fear of "messing it up." This artist was

not afraid. She had it all in perspective. There was no such thing as a "mistake." As a result, her pieces had an energy that was infectious, even as just a postcard stuck to a refrigerator. Think about that. It is so easy to tell ourselves that we have "done enough." It is so easy to justify taking it easy. The problem is that, in the end, a chain of such behavior will become regret. Don't risk regret. Take that next step. Make the call. Go above and beyond the call of duty. Your artist within does not pay attention to the clock on the wall or the logistics mounting against you, it only wants to help you create the changes you need. Fear and the desire to back off is a sign that your left-brain voice is feeling vulnerable. That is inevitable on the brink of any form of change. Focus on the next step, and only that. Then keep moving.

go to:
www.kaarenengel.com
to see work by Barbara
Hirschowitz

SUMMARY

Our "mistakes" contrast with our success. When you understand the element of contrast in your life, the wrong turns become pathways to new opportunities. Instead of feeling dejected, one looks for the silver lining. When others are saying "you shouldn't do that" or "it might not work," your artist within whispers, "What's the big deal? Try it." Your artist within understands the need for contrast. Don't be afraid to paint dark over the light or to stick paper collage over smooth paint. The canvas that is your life can only evolve into a richer and more diverse expression of you!

Exercises in RHYTHM

RHYTHM

Everyone has heard of people, especially children, painting to music. Have you ever heard music when looking at a painting? Maybe not, but picture in your mind a painting by Kandinsky. He uses pattern to create rhythm. Objects are repeated in his paintings—the rise and fall of the objects are like a musical tune. Pattern can also be used in our lives to create rhythm. Structuring my weekly schedule provides me with needed rhythm. Each week certain meetings are scheduled, and at certain times each month advertising campaigns go out and artists are contacted. By scheduling these tasks I don't have to spend other time making calls or wondering when to fit them in.

**Design
Principle:
Rhythm**

12 MANDALA
A JOURNEY BACK IN TIME

*At the still point, in the center of the circle, one can
see the infinite in all things.* —Chuang Tzu

Mandala is the Sanskrit word for circle. Mandalas are
a symbol of life and have been used by almost every
religion and culture throughout history. I came to know
mandalas as a traditional Native American ritual used
to promote a spiritual stillness, meditative state, or cen-
tering. Today this ancient ritual can be used to simplify,
quiet your mind, and to help you focus on whatever it is
that needs your attention. Mandalas may be ancient,
but they are long from being forgotten. A search on
the web for "mandala" reveals hundreds of resources,
including coloring books, graphic programs, online
courses, and more. Any artwork that includes a circle
can be a mandala. I am particularly drawn to the
Native American and to more geometric, symmetrical
examples of mandalas. Picture a bicycle wheel with
the spokes radiating from the center. Remember that
the circle is the universal symbol for unity. Designed as
a circle, the bicycle wheel has both boundaries and a
structure. Starting in the center is symbolic of our need
to focus. Focus on what? We may need to focus on the
core of the issue, our guiding principles, our intuition, or
our basic needs. The core of the issue may be hidden
by surrounding factors, but when you find the core, you
can find the solution. Remember the book *Breakout
Principle* by Herbert Benson and William Proctor? They

say that we have the answers to many of our questions tucked away in our subconscious and that we have "to get out of our left brain" to get the answers. This is a great exercise to use to do just that. I like to think of it as organized doodling. You let one shape follow another. Let yourself get into a rhythm. Don't overthink it. Whatever shape or symbol comes to mind, draw it.

Imagine this with me. You draw a large circle on a piece of paper and mark a dot in the center. Then, you draw a smaller circle around that dot. Next, the rays of the sun come to mind and you mark elongated triangle shapes radiating from the dot. There are diamonds in between each sun ray and a teardrop at their tip. Lines, like arches, hop from one teardrop to the next. A small circle, like a polka-dot, seems fitting at the crest of each arch and lines grow out of the top of each circle like eyelashes. Did you picture it? Can you see how your mind gets caught up in visualizing the image? As this happens, all those little thoughts, your internal to-do list, fall away like old rose petals until you are left with the inner core. Getting to that inner core is the goal of meditation. Using the mandala to get there is as effective as sitting cross-legged in the "om" position—and, frankly, easier. It is easier because of the sheer magnitude of business "chatter" flowing across our minds. If you want a breakthrough in your life or your business, give yourself the opportunity to focus on what actions you need to take to create the change you need. Meditation is being touted to CEOs by top corporate gurus as the key to reaching the next level

in their business. The popularity of yoga is fueled by our collective desires to center ourselves. Mandalas are another way to focus. They are another way to gain access to the untapped potential in our right brains and to listen to our artist within.

You needn't have any great issues to solve to want to create a mandala. To find stillness in today's hectic world is reason enough. Take some time for yourself and quiet your mind. Tell the chatter to go somewhere else. Your mind needs to rest, just as your body needs to rest. Aren't we happiest when we feel we have found rhythm? Everything seems to be working together when we feel rhythm in our lives. Before you start the mandala, imagine the waves of the ocean, the waves lapping at the shore over and over. Imagine yourself lounging on the beach at dusk with your eyes closed, listening to the surf. The rhythmic echo of the water as it laps the shore is mesmerizing and calming. **We can create that sense of rhythm in our lives by paying attention to what is really important and letting go of what is not.** In a painting, just a few brush strokes or contrasting colors can make—or break—the rhythm of a composition. If you took a brush loaded with muddy-brown paint and slapped it across a floral still life, it's safe to say that the rhythm of that painting would be broken. Your life is like a painting. What is its focal point and what elements are supporting it and what are detracting from it? These elements may not be as obvious as a muddy stripe of brown paint, so

what actions can you take, what brush strokes, which colors, to streamline your efforts to feel more centered and effective? Use the circle and the dot on the next page to try the mandala. Let these concepts sink into your mind and they will make more sense as the days go by. Give your mind a chance to help you discover your own rhythm.

In an effort to quiet the chatter in your mind, use the space below to write down your thoughts as they come into your mind. "I can't forget . . ., I have to call . . ., and so forth." By writing them down you are giving them a way out. Then, you can focus.

Make Your Mark...

At the still point, in the center of the circle, one can see the infinite in all things. —Chuang Tzu

Creativity Workout
MANDALA

Supplies

- Any kind of paper or your sketchbook.
- Pencil, crayons, markers, or pastels.
- A bowl that fits the size of your paper, for making your circle shape.

Workout

- Trace as large a circle as possible on your paper using the bowl. Feel free to freehand the circle if you are feeling brave!
- Let's read the chapter's epigraph, the words of Chuang Tzu, again: *"At the still point, in the center of the circle, one can see the infinite in all things."*
- Try to let go of any expectations. We can put a lot of unnecessary pressure on ourselves. Whatever you draw in the circle will be exactly what you are supposed to draw. Have fun.
- Draw a point in the center of the circle on your paper with your pencil. Draw shapes, like rays of the sun, emanating from the point in the center. Now add another shape and repeat it around your first shapes.
- Once you fill the circle, color it in with whatever materials you have handy. Pick the colors on the basis of whatever jumps out at you. Don't try to coordinate or organize. Let the colors pick you. Sound hokey? Try it. One color will catch your eye over another. Date your mandalas. Create one regularly in your sketchbook. Look back at them and note the differences.
- **More Ideas . . .** Create a mandala on watercolor paper with a fine-tipped permanent

marker and paint it in with watercolor. Try one with paints or collage. Again, the possibilities are endless!

SUMMARY

Giving yourself time to find your own rhythm is harder to do than it sounds. Winston Churchill painted amid a world war to create peace between his own two ears so that he could help bring that peace to the world around him. **You can pick up some computer paper and a pen, put a dot in the middle, and start doodling outward.** That simple act stimulates your right brain and gives voice to the artist within. Send an e-mail to your team at work and challenge them to bring a mandala to work. When you find your rhythm, your energies are focused and you find yourself paddling with the current. Enjoy the ride.

13 ABSTRACT TILES
SEEING THE POSSIBILITIES

Trust your intuition, it's just like going fishin'.
—Paul Simon

**Design
Principle:
Rhythm**

Picture a dance floor. You are sitting on the mezzanine overlooking the revelers below. Most are moving to the beat and do not attract too much attention. Some are better than others. Then, in the middle of the room, you spy a person who obviously has no sense of rhythm. She zigs when she should zag. Up when it should be down, right when it should be left. She is moving to an entirely different tempo from the rest of the group. That is a picture of what it means to lack rhythm in your life. It may not be as apparent in your life as it is on the dance floor, but you can feel it when you are in rhythm—you are moving along with the current, firing on all four cylinders, clicking. You can also feel it when you are off rhythm. You may say that you are "up the creek without a paddle." You feel that nothing is working in your favor. This is when you want to call up your inner artist. You can think of the principles of design and give your right brain something to do to help you gain some perspective, tap into your intuition, and make the necessary adjustments.

People who lean on logic and philosophy and rational exposition end by starving the best part of the mind.

—William Butler Yeats

The best part of the mind, according to Yeats, is the right side, the home of your artist within and your intuition. You need to "feed" that side of your mind. When you do, you will find your rhythm. Just by reading these words you are creating a new awareness within yourself. An awareness that will help you find your rhythm when you are in the middle of an uncoordinated life moment.

Just last week I was overwhelmed with several situations and exclaimed to Christy, my business partner, "Why can't anything be easy?" Even getting out the door with three kids, couldn't at least that go smoothly? Not last week. Everything was a struggle. We had lost our rhythm. I wanted to launch a marketing campaign for the wine bar and tHE aRT hOUSE: "It's just that easy! We'll cook you dinner, teach you how to paint—it's EASY." We had all five of our kids chanting at the nearby fast food palace, "It's just that easy." We were trying to conjure up easiness, like doing a rain dance. This week, in contrast, some of the scales are tipping in our favor. We can see the possibilities for good things amid the not-so-good things. It is times like these when you have to keep taking the baby steps. Keep moving toward the future you envision in your head, one step at a time. To help you keep moving forward, give your right brain, that side that Yeats extols in the quotation, something to do. In this exercise you are training your eye to see the possibilities that lie within some very simple materials and some very easy instructions.

I have a friend who is at a crossroads in her life. She has quit her job at a private school and is entertaining ideas of entrepreneurship. I have known her for years because she used to bring her kids to the Creative Fitness Center and now she brings her girlfriends to the wine bar, but she has yet to take an art class herself. After she told me about her ideas I sent her the introduction to this book. Here is what she e-mailed me a few days later:

> I LOVE your book! It really speaks to me, and frankly I can see it speaking to everyone. I can't tell you how timely your sending the excerpt was. I was literally crying to Clint the other night, scared to death, and wondering if I could really make this happen. Between his confidence and your inspiration, I know I'm going to be able to do it. I've already made more planning progress in the last two days than I had in the last 3 months! —HS

Of course, what made me happiest about this message was that she had been able to take some action, see results, and feel empowered as a result. She did not even have to do an art project. Just the awareness of the principles of design gave her new insight into her situation and gave her a framework within which she could operate.

Creativity Workout
ABSTRACT TILES

Supplies

- Heavier paper, watercolor paper, brown grocery bags, and cereal boxes are all ideal. Newspaper can be great too.
- Oil and soft pastels.
- Watercolor or tempera cakes.
- Acrylic paints.
- Glue—white glue or any craft glue.
- Water and brushes.
- Scissors.
- Acrylic spray gloss.
- Small, square shadow-box frames from any craft store. Black or natural wood works best.

Workout

- Make your marks with oil pastels. The marks are lines, squiggles, and curves. Remember the Drawing is Energy exercise at the beginning of the book? The hardest part is having to summon your inner two-year-old.
- Have soft pastels available for the third step.
- As you make your marks on each of the different papers, choose different color combinations. Use just black, white, and gray on one paper. Use earthy tones or blues and purples on another.
- After the oil pastel, paint over your marks with watercolors or tempera cakes. You will achieve a batik effect. Layer the paint colors. Let them

run together. The watercolors do not show up as well on the brown grocery bag or craft paper, but the soft pastels look fabulous!

•Apply soft pastels on top of the watercolor paints after they have dried, or directly on the paper. Blend the pastels with your fingers. Try adding colors on top of one another. Use warm colors together and cool colors together. Instead of just drawing with yellow, add some orange or red over parts of the yellow. Instead of just purple, add green and light blue.

•After the last step, you might try adding acrylic paint. Do you see how each additional layer makes the pieces more interesting? Experiment using the same color combinations with each layer, or different color combinations with each layer.

•After all your papers are painted and dry (you may have set them aside for a day or two, or even weeks or months, which is O.K.), cut each paper in half. Leave one of the halves whole and tear or cut the other halves into shapes and pieces. Glue the torn shapes onto the complete halves of paper with any kind of glue. Layer one piece on top of another.

•When you are done, find your favorite 3-inch-square sections. Cut out as many as you like into actual 3-inch squares.

•Spray the squares with clear gloss spray paint until they are thick with the gloss—which could require as many as 8 layers of spray gloss. They should resemble ceramic tiles.

•Float your "tiles" in the shadow-box frames. Hang them in a group or on a small wall in your home. Aren't you artsy!

•Now look back to the Paper Weaving exercise in the chapter on *contrast*. You may prefer to cut your layered pieces into strips and weave them together rather than making tiles of them. You can collage in old book pages, photographs, pressed flowers . . . Do you see all the possibilities?

What are some of the possibilities you have in your life right now? Taking a trip with a friend? Collaborating with someone on a new project? Selling a product of your creation on a website? Volunteering? Planning a party?

SUMMARY

We need both sides of the brain working together, in rhythm, to be at our most effective. If we are feeling overwhelmed on one side, we probably need to pay some attention to the other. The repeating squares in this Abstract Tile exercise bring rhythm to the marks and scribbles, paint and pastels. The squares provide a structure within which the creativity can work. Our artist within can bring rhythm to all the facts and figures, feelings and emotions inside our minds. When we find the right tune, new and exciting things can happen.

Exercises in **REPETITION**

REPETITION

Repetition can be used to draw our attention to part of a work of art. It often works alongside contrast and emphasis to communicate what is really important, and it contributes much to achieving unity. It makes me think of something my grandfather once told me. He said that knowledge breeds confidence. I tend to be a broad-brush kind of person. For me, repetition means disciplining myself to spend time gaining more knowledge. It means repeating a task over and over until I feel completely confident of my skill. Athletes utilize repetition to train their minds and bodies to perform a task without blemish. Scientists use repetition as an element in their research. When we force ourselves to use repetition, we sharpen the blade, creating the edge that will set us apart and ensure our success.

Design Principle: Repetition

14 MAGAZINE MOSAICS BUILDING BLOCKS—TAKE LITTLE STEPS

Imagination is more important than knowledge.
—Albert Einstein

Don't you love it when accomplishments come easy? It so seldom happens, but grab some old magazines, scissors, and a glue stick and this exercise will give you hope.

The tradition of mosaics dates as far back as 4,000 years ago, when broken pieces of terra-cotta were used for decoration. The colorful glass mosaics we all picture were first created by the Greeks. There are myriad mosaic tile sources today and mosaic books will leave you wanting to tile every surface in your home. The colors are so beautiful and the opportunities to create are endless.

I also think of the artist Chuck Close when I think of mosaics. He paints large portraits that, when viewed up-close, reveal a grid of multi-colored, abstract designs. Each cube of the grid works together to create an image. The pointillist masterpiece by Georges Seurat, *A Sunday Afternoon on the Island of La Grand Jatte,* also uses individual dots of color to create one of the most memorable images of our time. When viewed up-close, the shadows cast by the trees on the grass are thousands of green and red dots painted next to one another, much like a mosaic. Next time you are in Chicago, visit the Art Institute of Chicago to see this extraordinary painting. When I was a

child, my mother would take my younger brother and me to the Art Institute regularly and we would play a game, a sort of scavenger hunt, with postcards of the artwork displayed in the museum. We would split the cards into two groups and set out to find each painting pictured on the cards. I will be forever grateful for the opportunity to enjoy those masterpieces at such a young age. They exposed me to the concept that many small things can work together to create a unified whole!

Let me warn you about a tendency we all have. We want to compare our work, even as beginners, to the work of artists who have spent a lifetime creating their art. As one of my teachers loved to point out, that is like deciding to learn French and expecting to be fluent at the end of the first class; or showing up to run a marathon without having jogged a mile. We all do this with art. I can't think of anything else that we do that we expect to do perfectly right away. We don't expect to get the big promotion after the first day on the job, or to break any records in our first race, or to intuitively know how to navigate a new graphic design program. We accept that there is a learning curve and that we have to spend time to master the task at hand. We understand that *repetition* and experience are necessary to master any task. But with art, we think that we either "have it" or that we don't. In her book *Drawing on the Right Side of the Brain,* Betty Edwards writes about teaching children to draw. She hypothesizes that if we

We understand that repetition and experience are necessary to master any task. But with art, we think that we either "have it" or that we don't.

taught reading the same way most kids are taught to draw that everyone would be an artist, but only the gifted few would be readers! Imagine a teacher providing a stack of books in the middle of a group of kids and giving them no instruction except "read." Without the constant repetition, vocabulary drills, and "sight words," only a select few would learn how to read and inevitably the parents of the "readers" would say, "Well, you know, his grandmother was an excellent reader."

We all have the ability to create art. Some will naturally love it, and therefore spend more time (and repetition) learning and practicing. The more time we spend at anything, the better we get. Artists who devote their lives to their art, and do nothing else, create the pieces we see in museums and art books. Their devotion is to be admired and respected. I love telling my beginning students that Picasso had created more than 400 canvases by the age of fourteen. I tell them to bring me their 400th canvas and we will hang it in the gallery. **Until then, let's have fun, learn something new, and take the pressure off ourselves.** We are more accurately using art to gain access to a well of potential within our minds. As you use these exercises to tap into your inner artist, the goal is not to become master artists, it is to become masters of our lives.

A dear woman came to the Creative Fitness Center one day with a book of Matisse paper cut-outs. She was enthralled and inspired to create her own paper cut collage. As she showed me the book she exclaimed how Matisse had spent two years arranging and rearranging cut-outs

until he found the perfect fit. Twenty minutes later I heard the heavy sigh of frustration as she worked away at her first paper cut collage. I went over to her, patted her shoulder, and said simply, "two years." She immediately chuckled, relaxed, and gave herself a break. She was not in there to compete with Matisse. She was there to relax, to get inspired, and to break up her routine. We all need to let ourselves off the hook sometimes. Be aware of what you are saying to yourself and to what you are comparing your work, your life, your expectations. Don't give up on your creative ability because you don't see the results you expected. Remember the learning curve and Picasso's 400 canvases. Maybe you are expecting too much from yourself and simply need to spend more time or practice more. Maybe you have no schedule from week to week and you feel constantly overwhelmed. I often feel that way, especially during the summer when the kids are out of school and every week is a different adventure. Incorporating repetition into your life can relieve you of some of the stress. It could mean reserving Mondays for calling all of your salespeople, or for paying bills, working out, or going to the library after work. In this way, you are reassured that you will spend your time each Monday engaged in the same activity. In one fell swoop you are liberated from that nagging voice inside your head muttering, "When are you going to do this or that." It is amazing what a difference a small change can make.

All that said, this exercise is fun and easy. It is fabulous meditation. Play with this technique in your journal to start. You will quickly see further creative opportunities.

Creativity Workout
MAGAZINE MOSAICS

Supplies

- Old magazines.
- Scissors and glue stick.
- Your journal or any other paper.

Workout

- Cut colorful magazine pages into half-inch-wide strips.
- Then cut them into half-inch squares.
- Cut enough squares so that you have a variety of different colors.
- Divide your paper into 4 or 6 sections.
- Fill in the first section with your magazine mosaics arranged randomly, edge-to-edge so that there is no space between them.
- In the next section, glue the magazine mosaics into a simple pattern. Try other patterns in the other sections.
- Think of a quilt.

SUMMARY

Did you catch yourself admiring a little square of magazine? Each square becomes its own abstract painting. What had been an ad for bar soap is now a square with amazing shades of turquoise blue and green and looks electric next to the reds in what used to be an ad for a new hair color. **By repeating the same shape over and over you have drawn attention to the colors of the squares and together they have become a kaleidoscope of color.** When people repeat the same action over and over again they become experts. They become extraordinary in their field. They have learned through repetition—through repeating the task or repeating the act of seeking knowledge about a specific subject. Do you need more repetition in your life's design?

Taking It a Step Further...
MOSAIC MIRROR

If you have been inspired to do a mosaic, this project is really simple, but looks very professional upon completion. The art of mosaic is accessible to everyone these days. You may be tempted to tile every surface in your home. There are endless possibilities, made more enticing by the colorful squares of translucent glass available in any craft store. This project is a favorite of mine because it is so simple but yields impressive results. The repetition of laying each tile can be meditative and relaxing. These mirrors can be created in any size and are great for gifts or for creating a unique arrangement in your home. Invite the ladies over for a potluck happy hour and mosaic!

Supplies

- Quarter-inch to three-quarter-inch plywood cut to the size of your mirror.
- A piece of mirror cut at your local glass store to fit the plywood, leaving at least a 3" to 5" border for the mosaic.
- An adhesive such as Liquid Nails.
- Glass tile mosaics (Choose 3 to 4 different colors of tile. If you want blue to be a main color, for instance, choose two shades of blue. This will give your mirror a more professional look.).
- Mosaic adhesive and grout.
- Spatula.
- Tile nippers (available at any home improvement store) and safety glasses. The nippers are optional; safety glasses should be worn when working with glass.
- Newsprint and scratch paper and pencil.

- Rags to wipe away excess grout. Old cut-up T-shirts work great. Special sponges are also available in the tiling sections of home improvement stores.
- Plastic grocery bag.

Workout

- Place your mirror piece in the center of your wood and trace its outline with a pencil.
- Trace your wood piece and the mirror's position onto a piece of paper such as newsprint. This is just to help plan your design.
- Arrange tiles on the paper to create your design. I find the simpler the design the better. Don't obsess over it. It will look great regardless. Often I simply arrange the tiles randomly, leaving this step unnecessary. If you have chosen tiles of similar colors (for example, 2 to 3 shades of blue) along with a contrasting color (white or black always works well), this looks great.
- After reading the directions on the label of the tile adhesive, spread adhesive on one side of the plywood. This will prevent the grout from drying before you get the tiles placed. Spread the adhesive as thick as you would put cream cheese on a bagel. You do not want it so thick that it comes up over the edges of the tile, but you want the tiles to have something to sink into.
- Be sure to leave about an eighth of an inch between each tile to allow room for the grout.
- Tile the edge first. Be sure the tiles are flush with the edge of the plywood and that the machine-cut side is facing out, not the side you nip.
- To nip or not to nip? If you bought some tile nippers, you can cut your tiles into different shapes. My favorite is to cut them into quarters. This will increase your work time. They usually break evenly if you cut them along the grooves one way and the halves in the opposite direction. When nipping, place the tiles in a grocery bag so that pieces of glass do not get

in your eyes. Plan to wear safety glasses.

•After tiling the edge of your first section, work into the edge of your pencil line (where the mirror was traced). Be sure to leave that eighth of an inch here too so that your mirror will fit the space.

•Repeat until your plywood is tiled on all sides. Allow adhesive to dry. You can speed the drying by placing the project in a warm oven.

•Glue mirror onto plywood. Allow it to dry.

•If you purchased three-quarter-inch plywood, you can also tile the edge of the plywood.

•You can buy grout that is premixed. What a joy. The powder form is as easy to mix as a bag of Bisquick. Follow the directions on the bag.

•The trick to applying grout successfully is timing. Once you apply the first layer of grout, being sure to work it into all the spaces between the tiles and the mirror, wipe off any excess with a spatula. Allow the grout to set. This is hard to do because you have just covered your beautiful tiles with this ugly, cementlike mixture and you desperately want to wipe it off. You need to wait at least 30 minutes so that when you wipe off the excess grout you do not pull it out from between the tiles. Test a small section before proceeding.

•With a barely damp cloth or sponge, wipe off excess grout using a light, circular motion. Leave for at least 15 minutes, or longer, given variables like high humidity.

•There may still be a light film of grout on your tiles when you finish these steps. Wait several hours or even overnight for the final buffing, which is done with a dry, soft cloth or rag.

•You can seal your grout with a grout sealer, but this is really not necessary for mirrors. I have also tiled trays (which look great in the kitchen). Trays need to be sealed so that water does not seep into the grout and ruin your piece.

•Voila! You can apply these same steps to the backsplash of your kitchen or bathroom, flooring, and elsewhere. Be sure to ask tiling specialists at the home improvement store about your project so that

they can advise you on adhesive and grout suited to your location.

SUMMARY

Pick something, a hobby, a subject, a dinner dish, and apply the principle of repetition. Practice, research, and study. Notice the confidence that grows, and that as it grows, it spills over into other areas of your life. **Along with this confidence, you have also gained a depth of knowledge from which your creative side can pull new ideas and a new optimism.** During a recent corporate creativity workshop with a healthcare provider, the group recognized that certain members of the team were stretched too thin over multiple projects. Their work was repetitive, but in the sense of making them feel like the hamster on a wheel, never getting anywhere, not in the sense of accomplishment. These people were not able to see any one project come to fruition. There were no moments of "We did it." The workload was simply one thing after another. They needed to hit some goals and feel the satisfaction of a job well done. They left the art studio committed to helping each one find new focus. Sound familiar?

**Design
Principle:
Repetition**

15 QUILT PATTERN: REPETITION CREATES NEW OPPORTUNITY

There's only one corner of the universe you can be certain of improving and that's your own self. —Aldous Huxley

It is easy to take a situation we are in and place the blame on others. "We wouldn't be in this situation if so-and-so hadn't . . ." Huxley's words remind us that, no matter how hard we try or how justified we feel, we cannot control others. We can only control ourselves.

The challenge is often to gain a sense of objectivity so that we can see clearly what actions we need to take to improve the place we are in. Our artist within can be objective because its voice is not usually at the forefront of our minds and it is tapped into our subconscious. When we connect to our inner voice we start to see our "corner of the universe" in a different light.

Take a situation you are in right now. What does it look like? If it were a painting, what would it look like? Would it be dark, with just a few points of light, like a Goya? Busy and colorful like a Kandinsky? Rough-and-tumble bumpy like a Van Gogh? What do you want it to look like? Monet's water lilies? Whistler's landscapes?

I have applied the design principle of repetition to my own life. You know the scenario: there is too much going on and the schedule has gone out the window. You don't

know where you are going to be or what the agenda will be from one day to the next. It can drain you because of the energy it takes to keep up with yourself. Repetition reminds me that I need a schedule to help me cut the number of decisions I am making each day. Only yesterday I had to tell someone, "I can't be at the school today, but I am there every Thursday morning and could we do it then?" Problem solved. I stuck to my repetitive schedule of volunteering at my daughter's school every Thursday morning, thereby conserving my Wednesdays.

The key is taking control of your canvas, your corner of the universe.

You are the artist. Your life is a canvas, and that canvas belongs to no one else. The key is taking control of your canvas, your corner of the universe. Just like the master artists, we can use their design principles to help us see our next step. Would our life's canvas benefit from more unity? Has your team at work lost its focus because there are too many projects on the board without a common goal? Could you spend an hour in the boardroom re-unifying your efforts by defining your goal? What about proportion? Does a greater proportion of your time need to be spent asking the advice of others, learning more about an area of your industry, praying, working out, relaxing with your spouse? Use the design principles to help you take the steps you need to create change and to become creatively fit. Let's look at all the Design Principles together.

Design Principles

Emphasis • Balance • Proportion • Unity • Harmony
Contrast • Rhythm • Repetition

Circle one of the design principles above. How could you use it in your life to create some kind of change?

Circle another principle above. How could you use it in your life to create a different kind of change?

Repetition in the following exercise, and in the Mandala exercise in the chapter on Rhythm, can be very relaxing and meditative. Inspired by quilt patterns, it pulls from the tradition of quilting that is hundreds of years old. It makes

me think of the Atlanta ladies in *Gone with the Wind*, quilting in the middle of the Civil War when their world was collapsing around them. The quilting gave them a grounding activity that helped to keep them together. This exercise can do this for you!

Creativity Workout
QUILT PATTERN

Supplies

- Any kind of paper, ideally your sketchbook.
- Pencils, crayons, markers, pastels.
- A ruler if you like straight lines.

Workout

- Divide your paper into 6 to 8 segments with a pencil, marker, or pen.
- In the middle of each segment draw a simple shape—a square, diamond, circle, and so forth. If you have only 5 to 10 minutes to devote to this workout right now, keep your shapes larger and do not divide the paper into as many segments.
- Starting from the shape in the middle, add lines that connect the shape to the edge of each segment. Add another shape or lines into the resulting spaces.
- Repeat the pattern in each segment until your entire paper is covered.

- Color in your design. Change the colors in each segment. Since the design is repeated in each segment, the different colors will provide contrast.
- Experiment with various patterns and colors.
- Further possibilities lie in using different material to decorate each segment. What if you combined the Dream Collage exercise and this one? Use your cutouts from magazines. Cut them to fit the segments of your quilt design and glue them down, adding acrylic paint.
- Notice how the repetition of the design

you have created is relaxing. Once the design is drawn on the paper, you have only to think about the colors.

•Group project: Before your next meeting, give everyone a piece of paper and let him create his own quilt pattern. Just one square for each person. Then hang all of them together on the wall (with push pins or sticky tape). Talk about the difference made when they are all hung together. Can you achieve more as a group by working together? Each quilt block is different, just as each of us brings different strengths to the group. How can you capitalize on that more effectively? How could the design principle of *repetition* be applied to the subject of your meeting?

My daughter completed a project recently that reminded me of a quilt or mosaic. Her assignment was to commemorate her 100th day of kindergarten with a collection of one hundred of anything. She decided to create one hundred drawings (I was so proud!). We cut up different colors of paper into one hundred small squares, approximately 2" x 2". Within five minutes we were all drawing. It was amazing. We drew simple objects, flowers, faces, birds, scissors, houses, and even scribbles. Then my daughter mounted them on three different sheets of paper. She loved it. Try it yourself at home or at work with colleagues. At the beginning of the meeting, distribute 100 2" x 2" pieces of paper and tell everyone to "make his mark." It can get the juices flowing and everyone collaborating. Another great family or group activity follows.

Taking It a Step Further...
FAMILY RULES CANVAS

A great friend of mine is an amazing artist, entrepreneur, and mother of five! She licenses her artwork, designs, and ideas to be used on myriad products, from dinnerware to cards and bedsheets. Visiting her studio is a fascinating experience. There are sheets and sheets of beautiful patterns and designs, tubes and tubes of paint, brushes, scissors, pastels, everything you could possibly need. There are also five kids and their artwork and hobbies. This house has energy! One project I admired was her "Family Rules." It hangs above the fireplace in her family room, a colorful reminder of their family unity and love. Here is how to make one of your own.

Supplies

- Artist canvas.
- Pencil or pastel for outlining.
- Acrylic paints (the small bottles of craft paint work great) and brushes.
- Water.

Workout

- Decide with your family or group (could be a work family, a class-room, or another group) what your top five "family rules" are.
- Divide your canvas, horizon-tally, into 6 sections. *Important*: the lines here should be slightly askew. Draw them with your non-dominant hand or let a child draw them. To guide the child, mark a dot on the left side of the canvas where each line should start and let him draw the line across.
- Start with the top section. Write

"Family Rules," or a similar heading. Be sure the letters extend vertically from the top of the canvas to the first line you have drawn. See example #1.

•In the next section, write #1 and your number-one family rule. Continue until all five are written.

•Now you get to paint! With a stiff brush, outline your lines and words using the same color. I suggest black or another dark color.

•Once your outline has dried, paint it all again. If you like the colors, mix a slightly different shade (lighter or darker) and paint over the first layer, letting that layer peek through here and there. You may want to add a little white to some colors to make them cover better—it is hard to paint over dark colors with light ones. Let the project dry.

•Add any pattern to the different sections. Embellish as you desire. Have fun!

For more inspiration, courtesy my amazing friend, go to:

www.annamariahorner.com

223

Creatively yours, WHITNEY

The other day in my art class with a group of women in recovery, one of them said, aloud and unsolicited, "I love art class. It is the only place I can do whatever I want." That statement made my week. It made my month. That is why art is so important. It gives you something that you can't get anywhere else. Our ability to create is what makes us uniquely human. Artistic expression existed before the written word or a monetary system! We need to take art back and make it our own again in the twenty-first century. Remember the quotation from the Introduction?

> Before there were two worlds. The world of everything "out there," and the "you" that saw that world through the window of your eyes. Now there are three worlds. The world out there, the world "in here," and the world of things you make.
> —Peter London, No More Secondhand Art

What is not mentioned is that, after some practice, the third world of "things you make" will start to make its way back into your world "out there" and your world "in here." Like the wardrobe that led Lucy to Narnia, art and your creative workouts will lead you to new places in your own life that you never could have anticipated. New opportunities are created outside yourself when you start imagining the possibilities within yourself and

tuning in to your artist within. This is the true value of art and creativity.

My first "trip to Narnia" was when I opened the Creative Fitness Center. I confused the people around me because I had not been an "artist." My new life contrasted with my older pattern of existence. All of a sudden, there I was. I was the owner of an art center. I sold art that I had painted. I was the "creativity expert" on HGTV and the "craft lady" on the local news show. Eight years and three kids later, I did not think I could do it all by myself anymore. I needed a partner because I did not have the money to hire someone. I was overwhelmed and frustrated to be in that position after so much time. I needed balance in my life. There was too much that depended solely on me. I found a partner, but the results were not what I expected—my new partner and I opened a wine bar! Where did that come from? That really confused people. More contrast. Now I am a mother, a wife, an artist, the owner of an art center, and a restaurateur! When my logical, left brain, thought that I could not possibly do it all, my right brain showed me how even more could be done. The wine bar has been the unlikely vehicle that led to this book, a potential TV show, and a line of Creatively Fit products. It is a whole new world. A world and a life I could never have predicted. I love it!

You have a whole new world to explore within you, and your artist within and the principles of design are your tickets. Since it is your world it does not matter what it

looks like to others, or how talented you are. It is inside you. Are you really willing to risk leaving it as uncharted territory, to miss the proverbial "boat"? This world holds the keys to unlocking immeasurable ideas and opportunities. This world is inside your right brain.

When your brain is creatively fit it will give you strength that you never knew existed. Instead of being intimidated or overwhelmed by what life is handing you, it springs into action, imagining how you can create change, imagining what life will look like after you create that change, imagining who you will need to help you create that change, and imagining all of the opportunities that will result from your creative actions. Your *creatively fit* brain is also more open to new ideas and opportunities. Since it is empowered with a new self-confidence, a new belief in your ability to create opportunity, you will find doors opening to you that had been closed. They are opening because you have opened. You have opened that potential within yourself.

Your *artist within* is also inspired and energized. Its voice is supportive, encouraging, and empowering. A friend exclaimed to me just the other day, "How do you have the energy?" That question always puzzles me, because I do feel physical exhaustion. The other thing I feel, however, is an excitement and an anticipation, which is coming from my mind. It is a mental fuel that defies all the limitations and restrictions placed on our physical bodies by the need for food and sleep. This

mental fuel is always on tap and never sleeps. It can infuse your body with new energy to keep it moving forward. This mental fuel is stored in your right brain and fuels new ideas and inspires new actions. **These creativity workouts are like making a stop at the mental filling station, giving your mind an opportunity to fill up on what it needs to function best.**

Don't let your right brain run on empty. Even if this means no more than just picking up an art book, taking a walk, scribbling with crayons or a pencil in your sketchbook, cutting out pictures from a magazine, or walking through a fabric store—fill up your right brain. Exercise it with these creativity workouts so that it becomes stronger. Let the principles of design guide your decisions and give you new inspiration. Remember, your life is a work of art. Living the artful life, you will find yourself able to handle more of what is thrown your way, to think more positively, to imagine change, and to believe that **you can do it!**

Help your friends and colleagues to find their inner artist. Invite them over, ask them to bring the wine, and tell them you will provide paper and crayons. Spend the night coloring and sharing one anothers' dreams and ideas. Open your next office meeting with colors and paper. Help your colleagues to change their way of thinking so that you can all collaborate to create the change that is needed. Empower those around you to think creatively.

Each of the following people has inspired me, through a creative word. After each of these fabulous quotations, write down your reaction, your thoughts.

> *What lies behind us and what lies before us are tiny matters, compared to what lies within us.*
> —*Ralph Waldo Emerson*

> *We must accept that this creative pulse within us is God's creative pulse itself.*
> —*Joseph Chilton Pearce*

> *Do not fear mistakes—there are none.*
> —*Miles Davis*

All the arts we practice are apprenticeship.
The big art is our life.

—M. C. Richards

Let the wisdom shared by these amazing people whisper in your ear, your right ear. You do not have to feel amazing to create amazing results. None of these people quoted would tell you that they felt amazing. They trained their minds to produce amazing results. You have that same potential. That potential is your artist within. It is a voice and a perspective that our culture desperately needs. Our ability to create is directly proportionate to our ability to hope, to dream, to build, to solve problems. It is a concept that CEOs need to provide their employees so that they can innovate. It is a concept that parents want to instill in their children so that they will be able to rise to meet the challenges life will throw at them rather than backing down and giving up. It is a voice that people need in order to drown out the emptiness and apathy that can be felt from one day to the next. It is a voice and a concept that can be strengthened and flexed just like a muscle. Work out your creative muscles. Exercise them. Scribble, cut, paste, and paint. Fuel your right brain and you will be creatively fit.

Bibliography

Allen, Pat. *Art Is a Way of Knowing.* Boston: Shambhala Publications, 1995.

Arrieri, Angeles. *Signs of Life: Five Shapes Found in All Art and How to Use Them.* New York: Jeremy Tarcher, 1997.

Benson, Herbert, and William Proctor. *The Break-Out Principle.* New York: Scribner, 2003.

Boldt, Laurence G. *Zen and the Art of Making a Living, A Practical Guide to Creative Career Design.* New York: Penguin Group, 1993.

Edwards, Betty. *Drawing on the Artist Within.* New York: Fireside, Simon & Schuster, 1987.

Henri, Robert. *The Art Spirit.* Boulder, Colo.: Westview Press, 1984.

Kingston, Karen. *Creating Sacred Space with Feng Shui.* New York: Broadway Books, Bantam Doubleday Dell Publishing Group, 1997.

London, Peter. *No More Secondhand Art, Awakening the Artist Within.* Boston: Shambhala Publications, 1989.

Pink, Dan. *A Whole New Mind.* New York: Riverhead Books, Penguin Group, 2005.

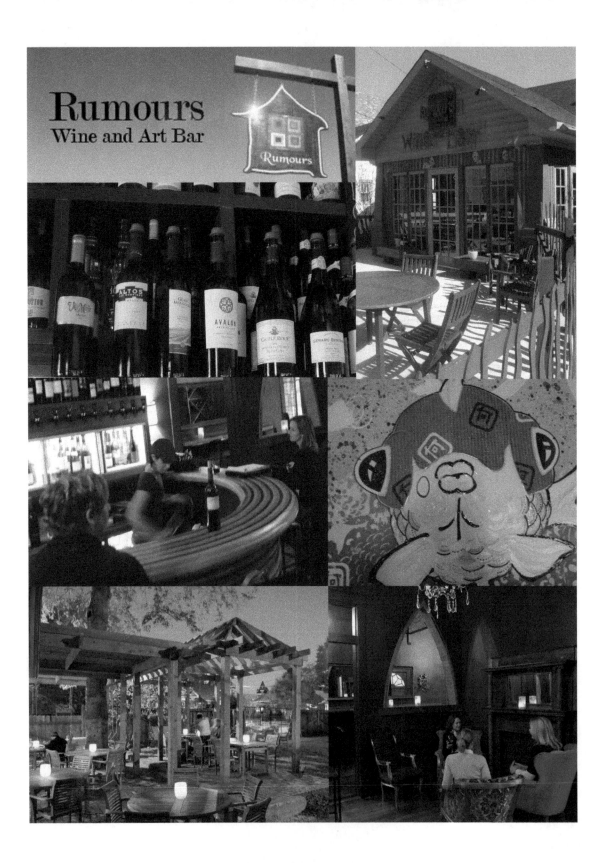

www.creativelyfit.com

Contact Whitney for creativity workshops, corporate team building, and speaking engagements.

View step-by-step images of the creativity workouts.

Order the supplies you need to work out your right brain.

Order Creatively Fit Paint Kits.
Great for your own right-brain workout or your work group, or even your Friday night painting party!

Order the Painting Made Easy DVD!

Book clubs and arty partiers! Learn about the wines you can taste at your get-togethers.

Template One

Template Two

Template Three